Praise for Fast Track Phot

"Dane Sanders has given you a priceless gift. Every once in a while, a book comes along that elegantly captures what you need to know to transform yourself and your business. This is that book. Read it, study it, hurry! *This is a great book.*"

Seth Godin
Author, The Dip

"If you're thinking about becoming a professional wedding photographer, you owe it to yourself to read this book. It's as much about finding out who you are as it is about how to become a truly great wedding photographer. Highly recommended!"

Amit Gupta
Founder, Photojojo.com

"With Fast Track Photographer, Dane does a masterful job of demystifying the complex world of professional wedding photography. This book provides an insiders' view of the industry while laying out a clear flight plan to success. I highly recommend it to anyone thinking about entering this competitive and rapidly evolving field."

Frederick V. Johnson
Senior Marketing Manager, Professional Photography
Adobe Systems, Inc.

"Dane has built quite a cult following in the world of wedding photography, and now we know why. In this book, we see all sides of his personal success, as visionary, mentor, and humble expert, effectively passing his secrets and foibles to an appreciative audience. I found his clear and direct vision of exactly how to build a successful business is only made more entertaining by the wonderful clarity of a great storyteller's voice. I read it twice—even though I was personal witness to many of the events Dane exampled within—because it was simply so much fun."

Jeff Jochum
Chief Marketing Officer
SmugMug.com

"Inspiring and concisely written, Fast Track Photographer provides a well-structured roadmap to help both emerging and established photographers identify and achieve their life's purpose."

Jason Kiefer
CEO, Pictage, Inc.

"Fast Track Photographer is completely fresh! The information is timeless, yet cutting edge, and applicable to any service business—but especially inspiring to new or experienced pro photographers. I've been photographing professionally for almost 20 years and it got me excited to take a new look at my business and ensure that I'm focused on my 'Signature Brand'. In a sea of "how-to" photography books, this lighthouse really stands out. It's destined to become a staple on every photographers bookshelf."

Kevin Kubota
Author of The Digital Photography Bootcamp®

"Fast Track Photographer is a dead on assessment of the working mind of the aspiring professional photographer. Dane is delightfully witty, thought-provoking and engages the reader on the most important steps needed to embark on a successful career in wedding photography. More than a specific "how-to achieve" book, Fast Track is a "how to think" methodology—which is way more potent. This book is worth its weight in gold and if you know anything about me, that's saying a lot."

Gary Fong
Photographer
Creator of the Lightsphere

"Dane Sanders Fast Track Photographer and pDNA are the best resources for today's photographer—BAR NONE!"

Scott Sheppard
Inside Digital Photography

"This book is unreal! Dane you knocked it outta the park with this and wedding PHOTOGRAPHERS are gonna be thankful for decades to come!"

David Jay
Photographer and Entrepreneur
Creator of ShowItWeb and ShowItSites

"Although I have a different take on a couple of issues, this is the most comprehensive, smartly written book about what it takes to make it as a wedding photographer in today's world. Dane has a gift for painting a picture of the industry with his words and wit and seasoned pros and newbies alike will benefit from his insight."

Becker
Wedding Photographer
Co-founder of thebschool.com

"If you've ever wondered what makes you and your photography business unique, look no further! Dane Sanders has created an invaluable resource in Fast Track Photographer! This book is filled with questionnaires, thought provoking stories, and in depth surveys for you to try. For every tool provided is the objective to help you identify your strengths and weaknesses as a photographer so you not only keep shooting but love the business of shooting too! Thank you Dane for all the hard work and hours you put into this! Fast Track Photographer is INCREDIBLE!!"

Me Ra Koh
Photographer, Author and Speaker

"Dane Sanders is a genius at breaking down advanced marketing ideas into simple formulas that everyone can apply. This book is a must read for any photographer who wants to skip the trial and error process and move straight into a successful career path."

Mike Colón
Celebrity Wedding Photographer

"Dane, you've hit the nail on the head! Identifying the need for clearly pursuing your career path as a professional, be it a wedding photographer or some other type of creative service based business. Fast Track is the outline to help you see the advantages of selling both the Photographer or Photography. Fast Track is an excellent resource to anyone considering becoming a wedding photographer. As Chief Photographer for Bella Pictures, and having my own signature brand, I will highly recommend it to all of our photographers. I love it, this is a must read!!"

Bob Davis
Chief Photographer, Bella Pictures
Canon Explorer of Light
Celebrity Photojournalist

"Dane's perceptive insights to the state of the wedding photography industry are laid out with dead-on accuracy. FTP is a must-read for anyone just starting out as a wedding photographer, but I would highly recommend it to seasoned professionals if they are interested in staying in the game. Dane's informal style of writing articulates his points in a very uncomplicated way that will clearly steer you into the right direction. Using engaging stories from the lives of many well-known photographers, Dane illustrates how you can apply the strengths you already possess to have the exact career you desire."

Jules Bianchi
Wedding Photographer

"I have a degree in business and this book is sound advice for a new photographer starting a new venture, or an established entrepreneur looking for a fresh start. It's interesting, articulate, and very well-crafted. Dane, your passion and energy palpitate throughout these pages...in other words, you rock!"

Jasmine Star
Wedding Photographer

"This book should be required reading at Harvard Business School and Brooks Institute. The concepts and ideals Dane portrays are vital for not just photographers, but for any small service based business. In the ever-changing world of digital imagery and wedding photography, those shooters with both a keen eye and a smart plan, will be the ones to rise to the top."

Ron Dawson
Creative Director/CEO of Cinematic Studios
Host/Producer F-Stop Beyond

"A wonderful insight into one of the most competitive fields of photography, a must read for the aspiring photographer."

Marcus Bell
Wedding Photographer

FAST TRACK PHOTOGRAPHER

The Definitive New Approach to
Successful Wedding Photography

DANE SANDERS

Second Printing

Cut Frame Press books may be purchased for educational, business, or sales promotional use. For information please write: Special Services, Cut Frame Press Inc., P.O. Box 12963, Newport Beach, CA 92658.

Cover Design by Elevation; Mike Green, Creative Director

Publisher's Cataloging-in-Publication Provided by Quality Books, Inc. The Library of Congress has catalogued this edition as follows:

Sanders, Dane.

Fast Track Photographer:
The Definitive New Approach to Successful Wedding Photography/Dane Sanders.
p. cm.
LCCN 2008905108
ISBN-13: 978-0-9817455-0-3
ISBN-10: 0-9817455-0-4

1. Photography—Vocational guidance. 2. Wedding photography.
3. Photographers. I. Title.

TR154.S26 2008 770'.23'2
 QBI08-600171

CONTENTS

ACKNOWLEDGMENTS

Like photography, gratitude should never become a commodity.

The challenge for me is to communicate that truth—the particularity of my thanks—despite the impossibility of the task. Despite my best efforts, for example, there will no doubt be people who should have been thanked here, who are not.

So, in acknowledging those who I've managed to bring to mind in writing these few paragraphs, my hope is that they would be seen as representing a larger group of individuals that have equipped and empowered me to get to this point.

In that spirit, I first want to thank the photographers who've blessed me and whose shoulders I stand on. Most notably, these creatives include David Jay, Brad Elliott, Mike Colón, Gary Fong, Chris Becker, Jessica Claire, Melissa Carl, Me Ra Koh, Brian Tausand, Robert Evans, Peter and Jana Thomsen, Amit Gupta, Bob and Dawn Davis, Jules Bianchi, Joy Bianchi Brown, Joe Photo, Jasmine Star, Marcus Bell, Jen and Stephen Bebb, Jeff and Julia Woods, Kevin Kubota, Jessica Strickland, Amy Nave, Mark Adams, Sara France, Jared Bauman, Nathan and Amber Holritz, Chris Humphreys and all my friends that make up the incredible communities at Open SourcePhoto and Pictage.

I'd also like to thank my sponsors who have graciously honored and supported this project from the very beginning. Specifically, Frederick Johnson at Adobe; Jason Kiefer and Jeff Jochum and their incredible teams at Pictage; Matt Bailey and Tricia Gellman Holmes at liveBooks; and the great guys at ShootdotEdit.

I'm also thankful to my church community at Rockharbor for inspiring and empowering my dreams of intentionally standing with and for photographers around the world. They have truly modeled what it looks like to give yourself away.

Further, Gary Sikes and the team at Elevation, most notably Jared Moody, Mike Green and Paul Mobley were the reasons this project actually made it to print. Thank you guys.

Of course, my early readers cannot be thanked enough. They along with my author friends seemed to intuitively know when to let me flounder and when to throw me a line when I was drowning. Special thanks especially needs to go to my wife (I'll say more about her in a second), my Mom and her husband Tom, Me Ra Koh, Tasra and Ron Dawson, Michele Mollkoy, Kathleen Doyle and Dan Tochinni. Your belief in me as a writer and as a human is a true gift. Special thanks need to go to my editor, Andy Wolfendon, who went above and beyond the call to make my words better for everyone.

To my Fast Track Founders who believed in this project before it even existed, I cannot thank you enough. This work truly would not have been possible without you. From the bottom of my heart, thank you!

To my kids—Drew, Abigale, Analise and Alaree—your sacrifice to bless your dad as he took on this crazy idea has taught me much. I pray the values articulated in this book affirm your own uniqueness. You are gifts in and of yourselves and my affection for each of you is making me a bigger person. Thank you.

And finally, to my wife Tami—you truly gave up much to allow me to tackle this lifelong dream. Your willingness to partner, stand for, cheerlead, fight for the good and break through to me with your love—despite myself—have made all the difference not only for this work but in my entire life.

It's to you and our children that I dedicate this work. I love you.

FOREWARD MOMENTUM

My first official meeting of Dane Sanders was at the WPPI trade show. WPPI (Wedding and Portrait Photographers International) is one of the largest gatherings of professional photographers in the country held each spring in Las Vegas. I have been attending WPPI for most of the twenty years I have been a professional photographer. Over those twenty years I have met and made friends with a handful of exemplary photographers; Dane Sanders is one of them.

One night at a gathering I approached him, as I had heard his name and thought I knew him by face but we had never officially been introduced. I began our meeting by saying "Hello, my name is Robert Evans and I wanted to ask you a question about your software Show it Web". He looked at me, smiled and graciously said, "Oh Show it Web was created by David Jay, I'm Dane Sanders." Yeah, okay, foot in mouth. I offered my apologies and Dane smiled saying, "Don't worry about it." We continued our acquainting in the corner of the room, and what seemed to have been inevitable happened. Our friendship commenced.

Since that meeting some years ago we have photographed weddings together, discussed business philosophies and shared our passion for photography. It is that passion that inspired us both to create a way to make learning photography more accessible to everyone who desires. We have both chosen our educational paths; Dane's has taken shape in this instrumental book.

In all my years as a photographer I have never encountered a book published like the one you are about to read. Whether you are getting ready to embark on becoming a photographer or are a seasoned pro, the knowledge and wisdom you gain will without a doubt help you mold or format the way you run your photography business. Reading this book and applying these techniques to your business will help you avoid making the same mistakes we have all made up to this point, myself included.

Fast Track Photographer is Dane's love for photography in written form in order to help you the reader define who you are or will become in photography while avoiding the pitfalls he himself ran up against. To write a book to help circumvent the obstacles he faced on his own path in photography is truly an act of compassion and that is what you are about to find out for yourself. (Merriam-Webster defines compassion as: sympathetic consciousness of others' distress together with a desire to alleviate it.) Dane Sanders' act of compassion in writing this book in order to make sure your path is laser sharp early on, will save you time, the most valued commodity in business, and more importantly, make you more money faster.

Imagine whittling a stick with a knife in an attempt to get it to a sharp point. You use the knife to slowly carve away at the stick, all the while being careful not to cut yourself. Just as in growing a business we try one thing then another, to find the quickest and most efficient way to reach our business goals. We may after many attempts find our way to accomplishing our objective, just like whittling that stick. When we are finished our stick/business strategy is honed in, however crude it may be. Reading this book will be like having your stick's tip sharpened in a state-of-the-art laser-sharpening machine. Your tip will have a precision razor sharp edge in a fraction of the time, giving you an edge over your competition.

In my own career I have watched the photography industry change at light speed. The opportunities today compared with when I started are far more numerable. The digital world sheds light on many new roads not available just ten short years ago. The learning curve with digital is much quicker than with film, most likely why you are a photographer today.

When I look back on my career over the last twenty years, one of the most important things I have learned is to keep moving in the direction of my goals no matter the obstacle. So long as I do, the universe keeps placing stones on the path in front of me on which to walk. Therefore,

if photography is truly your passion, then no matter the road blocks along the way just keep moving forward. The path you will travel in photography is waiting for you to make your footprint; go out and make an impression. It is up to you how deep it will be.

Capture the bigger picture and create value with your camera, and your career will flourish.

Robert Evans
Studio City, California

Robert has been shooting celebrity weddings and portraits for almost twenty years. Some of his noteworthy clients include Jim Carrey, Jenny McCarthy, Jennifer Aniston, Brad Pitt, Katie Holmes and Tom Cruise.

PREFACE

Setting You Up to Win

A Whole New World

If you're looking for a technical book on how to take better photographs, this is *not* the book for you. This is not a "how to" book, at least not in the traditional sense. This book has loftier goals. It is meant to tempt you into a fundamentally different way of approaching photography, one that begins not with the photograph but with something far more interesting: you.

The value in these pages has less to do with how to create better output and more to do with how to create a more valuable photographer behind the lens. The *Fast Track System* is about a new approach to becoming a professional photographer—in particular, a wedding photographer—at this radically unique moment in the history of commerce.

So, if you're just starting out or if you're beating your head against the wall wondering why all your hard work isn't working, this is the book for you.

But this is more than a book. It's a *system of thinking* that will first alter your take on who you are as a photographer and second, expand what you thought was possible for you in the world of photography. Finally, it will show you how to connect where you and your photography are today with what you were meant to be as a professional photographer tomorrow.

The only assumptions this book makes are that you are passionate about photography and that you're determined to generate wealth from it. With those two commitments firmly in place, let's take a ride that I hope will change much of what you previously believed about this craft and what you thought was possible for you to achieve.

Before you dig in, I want you to know that I've asked friends and colleagues who are leaders in our industry to give these ideas an honest shake. And to my great delight, the response has been tremendously encouraging, as you can see by the testimonials on the opening pages. I included these quotes not just to promote *Fast Track Photographer*, but also to give you some assurances that these aren't just a bunch of clever

ideas I made up. Rather, these ideas have been generated in the context of community. My decision to record them here is my thank you note to these incredible individuals who have given me so much. My intent is to take what they've shared with me, add what I've discovered for myself, and sift it all together in one place for you.

So, if there are things of worth that you take from here, I credit those in the industry who've helped me over and over again. Anything faulty, I take full responsibility for and invite your feedback on so we can all continue to discover and grow together. (To get in on that conversation, please consider joining our Fast Track Forum at (http://forums. fasttrackphotographer.com).

Ready, then? Let's get rolling.

GETTING STARTED

The Real You

Finding Your Edge

I bloom late. I always have. I remember in Junior High School feeling like the lone hairless wonder in a sea of testosterone-charged, baritoned and bearded classmates. But the funny thing was, I didn't feel bad about the slow pace of my hormonal development. In fact, I kind of liked it.

Because I looked less developed, I was usually seen as the underdog. And being the low guy on the totem pole has its distinct advantages. I often found myself in a classic win/win situation. For instance, when the classroom bully challenged me to an after-school duel, I was in great shape regardless of the outcome. I might be destined to lose a few teeth, but I couldn't really lose the fight.

You see, because I was the little guy, I was never expected to win. So, even when I lost, I got the sympathy vote, which was in itself a sort of victory. And if I managed to survive or even take a round or two (not a common event), I was seen as David beating Goliath. Another win.

The bully, on the other hand, was supposed to win. If he knocked me out he was…well, the bully. No real victory there. If I got lucky and tripped him or confused him, then he was the one who lost to the little guy. He had nowhere to go but down. Literally and figuratively.

What I learned on the schoolyard battleground was that, as the undersized late-bloomer, there was no way I could compete on the level of sheer might. There was no point in even trying. That freed me up to excel in those areas where I did have talents. I was quick with my feet, for instance, and could dodge a blow. I was even quicker with my mouth—could hurl funny insults that would get the crowd on my side. And in the likely event of my thorough butt-kicking, I had the social skills to turn it into a moral victory.

Entering professional photography at the age of 31, I felt as if I was up against some pretty daunting disadvantages. All of my budding photog-

rapher friends were about a decade younger than I. They were all single and had few obligations. They could take risks and make mistakes I couldn't afford. As a new husband and father working full-time as a college professor, the cards were stacked against me. Or, so I thought.

I forgot all about my late bloomer benefits.

I'll share more about my personal story later in the book, but the point I want to make here is that in the face of what felt like major obstacles to becoming a professional photographer, I chose to fake it. Rather than embrace the realities of my situation, which I perceived as full of liabilities, I tried to *spin* who I was and what I had accomplished in order to convince people I was something I was not. To use the school-yard analogy: instead of owning my clever-scrapper nature, I pretended to have bulk.

The funny thing was, it was an "early bloomer" friend that helped me find my way. He convinced me that if I wanted to make it profession-ally I needed to embrace who I really was, not who I wished I could be or thought I should be. Leveraging my most valuable resource—my real personality and talent set—would turn out to be the smartest (and only viable) option I could choose. In time, "being me at any cost" became my mantra. And to my great surprise, wonderful things started happening.

Not only did I start booking events and improving my photography and business abilities but I also became something of a people magnet. Because I felt at ease with who I was, I made the people around me feel at ease as well. I began to get exposure to some of the greatest names in the business by just being me.

There were certainly star-struck moments when I was tempted to play up my fantasy image. But even if I did momentarily give in to that im-pulse, I never found the experience satisfying. The more I became my-self the more these "brand name" photographers appreciated my candor and honesty. In time, these wonderful people became my friends. And

as they did, they helped me discover what I needed to know to truly flourish as a professional photographer. In fact, as I mentioned in the preface, many of the insights you're about to encounter are the gems these remarkable individuals have shared with me.

But here's the main point I want you to get: my career success began the day I became clear on who I was as a photographer and started sharing it with the world.

Where's the Real Value?

So let me state this unequivocally, right up front: the real value in any photography business is located in the person behind the camera. The tragedy is just how few shooters actually believe this.

As an analogy, think about a company like Starbucks. Does the true value of that business lie in its coffee bean inventory? In the prices it charges for its products? In its brick-and-mortar buildings? No, because if all the buildings and all of their contents were destroyed, the company would still exist and would soon be back in business again. That's because its real value lies in its ideas, its people, its signature style, its organization, its reputation, its vocabulary, its way of doing business.

To believe that either your inventory (i.e., your images) or the price you charge for it is where the real value of your company rests is superficial thinking. The real value is the engine that creates those images. The real value is *not* in the photography, it is entirely in the photographer who takes the pictures. The photography itself is the result of the photographer doing her job. Nothing more.

Let me state this as simply as I can: The goal of any business, if it intends to thrive in the long term, is to increase its real value. And the best way to increase that value is to invest in its core value engine. In the case of wedding photography, that core engine is YOU.

Learning to Fish

It is often said that it's better to *teach* a person to fish than to give a person a fish. Why would we intuitively buy that idea? Well, because simply receiving a fish can only give you short-term value. It cannot be reproduced. A handout is a one-time event. Conversely, learning *how* to fish gives you the ability to catch as much flounder as you'd like, for life. An investment in the *person* returns far more than simply meeting an immediate need.

In the same way, it would be a disservice to create a resource for you, the aspiring photographer, that simply talks about photography. That's like writing a "how to become a fisherman" book and only talking about the fish. Yet, as I look around the bookstore shelves, all I see are "fish" books. The idea that your inherent worth can come from what you create is a lie—and it is ruining people's lives. I've written this book to help set you on the right track as you start—or restart—your photo career.

So as this book unfolds, we will tease out—in detail—how you can define yourself as a photographer and then we'll empower you to leverage that identity to become incredibly successful. Sound good?

You Can Do This

Your dream of becoming a successful professional wedding photographer is closer than you think. Consider these facts:

» The barriers to entry for the photography industry are lower than ever before.

» Technology has taken much of the risk and guesswork out of photography.

» Online forums and other Internet resources offer you more photography and business "how to" advice than you could ever employ in a lifetime.

» Wedding photography is largely recession-proof because, rain or shine, people keep getting married.

» Wedding photography is a business that cannot be outsourced to other countries (though parts of it perhaps can and should be, as we'll discuss later).

Becoming a wedding photographer is also perhaps more alluring than ever before. Consider these facts:

» Wedding photography offers a creative career when the majority of the world's working population is drowning in a sea of mundane jobs.

» It allows you to control your own destiny.

» It is a business you can grow as large or keep as small as you want, especially given what I'm about to share with you in the pages to follow.

» Photography is one of the last truly creative professions you can join without being a child prodigy or spending many years in training.

This last bullet might seem particularly appealing. Like "rock star," professional athlete or movie actor, the title of professional photographer brings with it a magical "sexy factor" unavailable in most other professions. For some reason, people just seem to hold working artists in high esteem. Becoming one of the "lucky few" can raise your social stock considerably.

But the reality does not always measure up to the promise. Why? The truth is, the wedding photography industry is littered with exhausted shooters barely making ends meet. Further, many millions of new Digital SLR cameras were purchased over the last couple of years, each one representing another aspiring enthusiast who might become a professional at some point down the road. Go on any online photo forum these days and you'll find thread after thread lamenting all the "newbies" coming in and "stealing everyone's business."

But how can this be? With so much potential on the table, why would veterans in the photography business be upset when new, largely untrained enthusiasts join the ranks?

It's because many of these veterans made a critical mistake in how they built their businesses in the first place. They chose to compete in the photography industry rather than the photographer industry. In so doing, they've come to believe that their core competency is in creating pictures. The challenge for these folks is that it's getting easier and easier to do that part of the job. Anyone with a DSLR can now be seen as potential competition.

If, on the other hand, the "enthusiast wanting to go pro" (say, you) makes the fundamental decision to make their business not about what they create but about the *photographer* they're seeking to become, guess what will happen? The competition will never materialize. It can't. Why? Because "you" is a scarce resource that cannot be easily copied. And as Seth Godin, author of brilliant marketing books such as *Meatball Sundae* and *Permission Marketing,* so astutely observes, if you increase scarcity, you increase value. As I'll explain in the pages to follow, in the monopoly of "you," there is only one player in the game. In the category of "photography," there are literally thousands of new players every day.

Where Most Photographers Go Wrong

I was speaking recently to Jason Keifer, CEO of Pictage, the world's largest professional lab for wedding photographers, and he estimated that somewhere between 150,000 and 250,000 photographers in the United States shoot weddings. And with the influx of so many new DSLR owners, that number is proliferating at breakneck pace. Yet, there are only about twenty to thirty thousand photographers who shoot more than ten events per year. Of those, most are putting themselves in competition with all the new shooters because they choose

to compete over the commodity of photography. Only a tiny fraction of those "full timers" make their business about the one thing that is competition proof: the unique photographer himself/herself.

Michael E. Gerber, author of *The E-Myth Revisited and Awakening the Entrepreneur Within,* does a great job of explaining what is required to succeed as an entrepreneur. According to Gerber, of the million or so new businesses started each year, some 80% fail in the first five years. Another 80% fail in the next five years. That means that after a decade, only 4% of all new businesses are still standing.

He then goes on to explain how most of these "entrepreneurial" efforts begin. The story usually goes something like this: A business owner hires employees to help move the business along. In the process, these employees gain expertise at the skills required of them. Over time, they notice that their income is smaller than the owner's yet they seem to work harder on the "core task" at hand. They decide to strike out on their own.

In the wedding photography industry, this often happens with associate shooters. The associate starts to become very good at taking pictures (the perceived core competency),. Then he or she thinks, "Why am I using my talents to promote another person's business? I can do this on my own!" And off they go to start their new venture!

But the reason so many upstarts fail is because *starting* and *running* a successful business requires far more than the ability to take good pictures. There's marketing, customer relations, bookkeeping, contracting, job management, equipment maintenance, and countless other jobs many *aspiring* entrepreneurs simply don't plan on.

These challenges are very real. But in my estimation, the biggest reason most new service-based businesses in our current age fail is this: they make their business *about* the wrong thing.

They get the core all wrong. And in today's business world, that mistake can be deadly.

Two Main Paths

I've made the point (and will make it many more times in this book) that your core value as a photographer does not come solely from the photography you create. It comes from the photographer you are. That said, there are two main career paths we will be discussing in this book. The sooner you decide the primary kind of business you want to create, the sooner you will be on the road to flourishing success. The great news is that you can change your mind later and/or find intriguing ways to combine the two.

In building a *photographer*-centric business, you can either create a *Freelance Photographer business* or a *Signature Brand Photographer business*. In both cases, your value comes from you, the photographer. But what you're selling and the way you sell it will vary.

The difference between the Freelance Photographer and the Signature Brand photographer is simple. The Freelance Photographer does fee-based assignments for employers while the Signature Brand Photographer functions independently and builds a commercial brand around himself/herself. Both paths involve knowing who you are as a photographer—your strengths, your loves, your tastes, your circumstances, your weaknesses and your skills. Both paths involve selling yourself as a photographer, but both require doing it in different ways.

Opting to become a Freelance Photographer takes many roles and responsibilities off your shoulders. Typically, jobs such as selling the company's services, meeting with prospective customers, booking weddings, etc., are done by the employer. Your job is mainly to shoot the event and do whatever follow-up tasks may be required.

Knowing yourself is the key to deciding if this path is right for you. If you are the type of person who honestly does not enjoy marketing, building a customer base, interacting with prospective customers, assuming business risks, etc., then a Freelance Photographer approach

may suit you best. Of course, the ultimate *rewards* are more limited than they are for the Signature Brand Photographer, but if you just like the "taking pictures" part of the job, then becoming a Freelance Photographer allows you a way to make good income doing something you love.

As a Freelance Photographer, your focus bends more toward the photography than the photographer. But you still must develop yourself as a photographer in ways that distinguish and enrich you personally. You may discover, for example, that you excel at outdoor photography in natural light. Or you may find that you have a gift for loosening people up and a knack for capturing poignant, unrehearsed moments. Because you recognize and play to these strengths, when jobs come up that require your particular personality and skill set, you become the "go to" person that everyone calls.

The Signature Brand Photographer is different. You have a more complex set of requirements because you are selling a less intuitive product: yourself. Your brand is the person behind the photography. When someone hires a Signature Brand Photographer, it's the person holding the camera they are hiring. To become a successful Signature Brand Photographer, you need to have a good objective sense of who you are, how to brand yourself, and the value you represent in the marketplace. Ideally, you are someone who is comfortable doing marketing work or at least working closely with marketing professionals. You should be someone who enjoys being in the foreground, who brings a strong persona to the table and has natural leadership qualities.

Signature Brand photographers can sometimes choose to do freelance work but it can be challenging for a Freelance Photographer to suddenly become a brand. The reason many photographer businesses get into trouble is that they fail to clearly choose how they want to be perceived by the end user.

For those of you unfamiliar with my work, I want to state right up front

that I have chosen the Signature Brand route for my own career. I find it offers me, personally, the greatest opportunity to leverage the new business landscape in which we find ourselves. Throughout the book you may feel that I'm putting slightly more emphasis on the Signature Brand option. I own that this may be the case. There are two reasons for this: (1) I am more intimately familiar with the ins and outs of the Signature Brand option, and, more importantly, (2) the Signature Brand route, by its nature, is more complex than the Freelance route. There are simply more factors to explore and understand.

But I want to be very clear about this. You and I are different. I am not advocating one career path over the other. Both are viable paths for the professional shooter. The people who get in trouble are the ones who fail to decide their core business model and get caught in the middle.

An Exit Strategy

Of course, some of you will get to the end of this book and realize that becoming a professional photographer *at all* is not for you. In that case I will applaud your courage for acknowledging reality and for checking this profession off your list. I hope my work here can serve as a catalyst to get you to a clear decision point as quickly as possible.

The principles behind what I propose in this book are transferable to almost any service-based industry. So if you're wondering if you're in the "I don't think this is for me" camp, I encourage you to resist the temptation to decide now. Finish the book. Anything worth doing well is challenging at the beginning and I wouldn't want you to interpret challenges as signs that you shouldn't do it. Also, by finishing the book you may learn something about starting *any* kind of business and that learning may prove invaluable.

For many photographers, it isn't that they *shouldn't* go pro, it's that they shouldn't go pro *in the way* they currently envision it. Wrapping your

profession around your uniqueness will set you on the right course. But, if by reading this book, you discover that going pro as a photographer isn't for you, I will have done my job as an author and perhaps saved you a great deal of money and heartache.

On the other hand, these pages may ignite in you an even fiercer determination to start your own photographer business. Either way, I have little doubt your perspective will change.

Attitude is Everything

When I look at the current state of wedding photography, I'm struck by how contrasting our times have become. The polarization between the successful photographers and the struggling ones has never been so stark. In fact, I believe that in the very near future there will be no "middle ground" photographers left. Those who now dabble in the industry will either become more sophisticated or drop off the grid. Those who've been at the trade for some time but fail to adjust to realities of our age will also disappear. For them it will be a self-fulfilling prophecy: they'll be overtaken by newcomers who are willing to evolve and adapt. And as they fall from grace, they will become more and more resentful that the "newbies" are "stealing their business." They will end their careers bitter and angry.

But if you've picked this book up and read this far, I suspect you are of a different stripe. You've probably not been infected by the negativity virus yet. You are an enthusiastic photographer, still moved by the magic that is photography. The thrill of capturing life with light is your passion. The idea that you could translate that labor of love into paid employment is a dream you've barely given yourself permission to say out loud. But in your heart you feel you might just be courageous enough to take a swing, if only someone would lend you a hand.

That's what I'm here to do. I hope with all of my heart that I am successful.

How to Best Use This Book

To get the most out of this book, I suggest you start at the beginning and read through to the end. But, of course, it's your book; you can choose to jump around if you prefer. In either case, here's what to expect as the book unfolds.

In *Chapter One*, we'll discuss the current state of the photographer industry as well as how you can best navigate the terrain with ease and grace.

Chapter Two offers an explanation of how the whole Fast Track Photographer System works.

Chapter Three begins the process of personalizing it. It's here that I introduce you to the Photographer DNA (pDNA) Assessment Tool available free with the purchase of this book (for more information, go to http://fasttrackphotographer.com). This interactive tool helps you assess the kind of photographer you were made to be.

In *Chapter Four*, I apply the pDNA test results to my own story to help you see how it works from an objective point of view. My results, of course, will be different from yours. But I hope that my personal "tell all" of how I discovered these insights the hard way will save you a lot of grief.

Chapter Five invites you to paint a picture of the photography life you've always dreamt of living. With the knowledge you have gained as a result of the pDNA Assessment Tool, your vision will become more vivid than ever. I will ask you to imagine, in detail, what your life might be like as either a Freelance Photographer or a Signature Brand Photographer and to then compare these models with the dream that started you down the road in the first place.

Chapter Six will then empower you to connect the dots between who you are and what you aim to become. I will help you analyze your own pDNA and then choose the career path that seems most true to your results.

Depending on whether you want to become a Signature Brand Photographer *(Chapter Seven),* a Freelance Photographer *(Chapter Eight),* or some hybrid in between, you will be set up to win. You will come to better understand how to approach your new business to leverage our Digi-Flat times. You'll get a good sense of the types of tasks you'll want to execute yourself and those you'll want to share with your action and support team.

Chapter Nine takes a look at some of the universal concerns you'll need to address as you start a Photographer business, regardless of which business model you choose.

Finally, *Chapter Ten* offers a brief send-off into your new photo life with some challenging thoughts and some words of encouragement. By the end of this section, you should be fully equipped to become a *Fast Track Photographer* faster than you ever thought possible.

Okay, you're officially on the *Fast Track*. What are you waiting for?

CHAPTER ONE

A New Era

The Grumpies

Once upon a time there was a guy named Frank.

Frank wanted desperately to become a professional photographer. He just didn't know how. Drawn to the power of pictures, Frank fantasized that if he could make a career with a camera, he would be living his dream.

As an outsider looking in, Frank believed that to make a mark in the world of photography the first thing he needed to do was learn how to take pictures. Not knowing any professionals under whom he could apprentice, he concluded that he should go to school to learn from the "masters."

Frank enrolled in the most expensive school he could find. He had been convinced by the school's financial aid counselor that his "low interest" student loans would be paid back almost immediately upon graduation. Frank was surprised at how easily he was accepted into the school, given his lack of experience. He had never actually owned a camera besides his mom's "point and shoot." But he set that concern aside and assumed the career gods were smiling upon him. Perhaps he really did have the potential to be great, just like the admission salesperson—er, *counselor*—told him.

It didn't take long before Frank began to feel like he knew what he was doing. He learned to sling the jargon around like a pro. SLR, ISO, EOS… In time, he found himself able to accomplish things with a camera he never knew were possible. His instructors started telling him that his skills were "showing merit" and Frank started to believe them.

In the process, Frank began to take on a new persona. His wardrobe became trendy and his hair stylized. He even changed his name. He announced that he wanted to be called *Franz* from now on, to "honor his Germanic roots."

His friends didn't like hanging out with him as much as they used to (evidently Frank was more fun than Franz) but they were impressed

with the pictures he took. And, with little else to talk about, they told him so. That's when Franz first contracted the disease. Prima-donnitis —a medical pre-condition for the more serious illness known commonly as The Grumpies. Perhaps if he had received an early diagnosis or had at least been warned that such a malady existed, he might have been able to steer a course back to health. But, alas, he did not.

In his final year of school, a famous celebrity-wedding photographer came to address the students. Franz attended the event not because he had any aspirations of becoming something as lowly as a *wedding* photographer. No, he came because of a circulating rumor that this particular photographer had become incredibly wealthy through his craft. Franz thought, "Maybe I could learn a few tricks from this guy."

Franz immediately put up his critical filters, though. He didn't approve of the speaker's casual presentation style or of how little he addressed technical aspects of shooting, dwelling instead on "softer topics" such as shooting large events efficiently, managing customer experiences and marketing. But of course, the main reason Franz discounted most of what he heard was that he felt it simply didn't apply to his career path. And, tragically, he was right.

Franz graduated from photo school with three prime assets:

» A substantial amount of technical knowledge on how to take great pictures

» A diploma that seemed to indicate he was now qualified to shoot professionally

» A six-figure student loan

Despite the optimistic promises made by the school's placement office, the only tangible work opportunity he could find was a post-graduate apprenticeship with a fashion photographer from Los Angeles. When he showed up for the interview and saw a hundred other applicants in

line, Frank gulped. *Franz,* on the other hand, put on his "blue steel" persona and proceeded to nail the interview. He thought he landed the apprenticeship because of the quality of his portfolio and his artistic presence. In truth, he got it because the employer observed how enamored he was with the whole idea of fashion photography and reasoned that he'd probably work harder than anyone else.

True to prediction, for the next nine months Franz worked 60 hours a week in the unpaid internship and spent another 32 hours a week working at a local Starbucks. His willingness to work was never in question.

Franz didn't make many friends at the coffee shop, despite displaying the appropriately hip demeanor. The impression he gave his peers was that he was a little too good for the job. He couldn't imagine how this kind of work would benefit him in the future. His "over it" attitude showed in everything he did.

When Beth, a co-worker, discovered Franz was a trained photographer, she tried to befriend the "artiste" around their common passion. Beth hadn't gone to school to learn photography. Instead, she had saved up and bought a digital Single Lens Reflex (DSLR) camera and a basic lens. Her education consisted mainly of shooting as often as she could and not taking herself too seriously. Unlike Franz, she seemed to have fun with her camera. When stumped by a technical question or looking for a little inspiration, she would hit the online photography forums where she got her questions answered and found new friends. She also spent time reading her camera manual.

After some nagging from Beth, Franz finally checked out her photoblog and was surprised with what he saw. "Not bad for an amateur," he thought. The budding friendship faded, however, as Beth was promoted to assistant manager at another store and Franz was too busy to return her calls.

Some months later, Franz's apprenticeship came to an end. That same

day, significantly enough, he was fired from his job at Starbucks. His supervisor said that he was never really "there" and couldn't seem to understand how important it was to create a positive experience for the customer. Franz was the best coffee maker at the store. He just wasn't a very good *Starbucks barista*.

Franz had to find work somewhere. Searching *craigslist* he found an opening for a "photo assistant" for a wedding photographer. He was surprised to see that the job actually paid money. He reluctantly made the call and was shocked to hear Beth's voice on the line. Beth remembered Franz. She didn't have time to interview him at length because she was so busy, but she trusted that since he was professionally trained, he would be a safe bet. She offered him the job.

Beth's journey into the professional ranks had been quite different from Franz's. She shot her first wedding for a friend. Beth quickly discovered that people not only liked her pictures but fell in love with *her*. Referrals began to pour in and with the money she made, she invested in a website and professional-grade equipment. In time, she was making more revenue from weddings than from her Starbucks job, so she chose to let the latter go. She kept connected with all her co-workers, though, and over the next thirteen months ended up shooting five former colleagues' weddings, including that of her former boss.

When Franz came to work for Beth, he was privately critical of her work and believed he was much better than her. Out of respect for the fact that she signed the checks, though, he kept his opinions quiet and did his work diligently. Franz wasn't a bad guy, he just had a misguided attitude.

After observing a few of his client interactions, Beth decided she needed Franz to focus on areas of her business that wouldn't affect the customer experience she was trying to create. Franz was irritated at having to do things like carry Beth's bags and "Photoshop" her images. He also didn't like telling his old photo school friends that he was working for a wedding photographer. But he was paying his bills and making

his money from photography. Many of his old classmates weren't even doing that.

After a year or so of assisting, Franz's frustration soured into resentment. He couldn't believe how much money Beth was making "on his back." With the cash he had managed to save (Beth paid him very well), Franz decided to start a wedding photography business of his own.

The shift from employee to owner was brutal. Franz discovered that he was totally naïve to the realities of running a business. After the first six months, he realized that he had made less money as the owner of his own business than he had when he was Beth's assistant! And with all the administrative tasks he now dealt with, his weekly work hours had tripled, lowering his hourly earnings that much further.

Franz needed to find an edge. He decided to distinguish himself by making his business "photo-centric." He believed his greatest asset was his ability to create remarkable images. Unlike Beth, who outsourced much of the laborious work of her business, Franz believed if he had greater *control* of all aspects of his work, he would gain an edge over his competition. Being the industrious worker that he was, he built his own website showing off his amazing pictures and added a shopping cart function to take orders.

Franz took care of everything himself: from bookkeeping to taxes to contracts to order fulfillment. As a result, he always felt way behind and overwhelmed.

Franz sometimes ran into Beth at trade shows and conferences. In person he would smile and hug and reminisce about old times. Inside, though, he was resentful that she was so popular, often being asked to serve as keynote speaker at these events.

"Why doesn't anyone know who I am?" he wondered. "Don't they know she's all marketing and no substance?"

Franz felt invisible. And, he was—both to his colleagues and potential clients. Despite his best efforts at optimizing his website and buying up what advertisements he could afford, people weren't booking him beyond a modest stream of low-budget weddings.

Through sheer willpower, he managed to bring in more business over time. Franz couldn't seem to raise his prices, though, and had to shoot constantly to stay afloat. He began making a dent in his student loans and maintained a steady $45,000-a-year business as long as he shot a lot. Franz felt he was coming into his own. He "found his voice."

Franz stumbled onto an online photo forum. In less than a year, he logged over 6000 posts (not counting the 660 posts he made under a fictitious avatar) and became known as the "Franzinator" for his insightful flames of "newbies" asking "idiot" questions in the Pro section of the pay-for-access forum.

Franz developed some admirers who liked his bold assertions. A crew of like-minded avatars joined him in playing the "artiste police." It felt strangely satisfying to be crotchety *together*, even if they were actually alone in front of their computers in a blue-lit room at 2 a.m.

This year, Franz's income has dropped to $39,000. He attributes the loss to the flood of new DSLR owners who have entered the marketplace and are sapping business away from the more "qualified" pros. This makes Franz angry. Rather than channel his energy into learning new ways to adapt his business model to a changing world, Franz devotes more and more of his time to his online rants. Without realizing it, he has come to believe that driving newbies away from his profession is the most effective way to reclaim some of the lost business he believes is rightfully his.

Franz has developed a terminal case of the Grumpies. He has nowhere to go but down.

The Grumpy Photographer Life Cycle (a.k.a. the Road to Hell)

I wrote this not-so-fictional tale to make one simple point: don't be Franz. You do have an alternative.

What you hold in your hands is a roadmap for change. And whether you picked it up with the hopes of a future in photography or as someone already infected with *the Grumpies,* starting to look at our world differently will be Job One if you are serious about getting on the road to success as a gloriously free wedding photographer.

Below I've laid out, for emphasis, the stages of the Grumpy Life Cycle. For established photographers who are reading this book, please don't shoot the messenger. If any of the following stages remind you of yourself or "a friend," don't despair; view it as a wake-up call. (Wouldn't it be ironic if you became even Grumpier defending yourself against charges of Grumpiness?)

The important point is that if you're willing to eat a little humble pie, there's still plenty of time for the antidote to kick in. Who wants to live their whole lives as a *Grumpy* anyway?

Here's how the *Grumpy Life Cycle* often plays out:

1) An enthusiast gets inspired by photography and decides he needs to go to school to learn. (I'll use the male pronoun here, but obviously it could be a "she" as well.) He borrows lots of money to become an elitist-minded, technically sound photographer. Despite his bias against wedding photography (and people in general), he gives in and decides to bless the wedding industry with his presence. Voila: The birth of a *Grumpy.*

2) Loaded down with student debt, the freshly minted Grump decides to expedite his career by becoming an Assistant for a more established photographer. His hopes and attitudes quickly erode as he

discovers that toting bags and holding light poles isn't much fun.

3) In time, the Grumpy becomes a "second-shooter." He gets to actually take pictures. This is good news. He finally has the chance to get in the game. He soon begins to think he *is* the game. He fails to realize that the whole point of his job is to serve someone else. He decides to start his own business because he thinks he can do it better (or he quits altogether).

4) The Grumpy now takes on risk and debt by hanging out his own shingle. He starts spending money/credit on advertisements. He may even open a brick and mortar store, hoping his mere presence on the block will trigger an avalanche of work. "Spend money to make money" becomes his mantra. The concept of *investing* gets missed. Paying off existing debt or actually saving money is not even on his radar screen. As a result, a dreaded second job is often required to pay the bills.

5) The Grumpy finally realizes that no one knows who he is. His studio looks great but it functions primarily as a wastepaper basketball arena. His online presence is overly eclectic and tiresome. In desperation, he hires someone to update his website. The realization that Wedding Photography is a highly competitive profession is beginning to sink in.

6) The Grumpy begins to land some work. Sadly, he takes credit for it. In reality, the seasonal nature of the industry has created more demand than supply during the booking season. He gets hired because clients need to hire *someone* and he happens to be available.

7) In isolation, the Grumpy begins to wonder if other photographers could help him get his career in gear. He begins stalking blogs and hanging out in online forums, soliciting free insight. Others aren't attracted to him because he forgets that fruitful transactions require *both* parties to contribute. The Grumpy takes but does not give. He

manages to network with other "takers" and they form their own Grumpy Network. They begin to feel like a community. They spend way too much time ranting to each other and especially to newcomers to the industry. They begin to infect others with the virus.

8) The Grumpy discovers that the business he's created is non-scalable, meaning that he is personally required to do more work in order to make more money. He becomes a bottleneck to success. Still unclear on what his core business is, he takes on as many jobs at market prices as he can. On rare occasion, he turns a profit through this volume approach to business. This is the worse development because *earning* money, in his mind, validates *how* he made the money.

9) The Grumpy gets addicted to making money this way. He no longer even likes photography. He begins to dread taking pictures. He is tired and burned out. He becomes protective of the scarce business he's created, going on the warpath against newbies and innovators. The Grumpy has no motivation to change.

10) The once passionate amateur lives this Grumpy, unfulfilled life until he retires or finds a better occupation. The tragedy is that his Grumpiness is portable to any industry and the likelihood of recovery at this point is slim.

A Beth or a Franz?

The real tragedy of the Grumpy Life Cycle is how avoidable it is. It's almost as if the "dark side" gets hold of genuinely good people and sours them on their journey. Whether it originates with their training, the professional influences they choose to absorb or just a stubborn sense of pride, the results are the same: Grumpies are plagued with a serious and debilitating disease that is quite hard to cure once it sets in.

Fortunately, we have another model. Look at Beth. She too is a not-so-fictional character. As you immerse yourself in the wedding photog-

raphy industry, I suspect you'll be able to quickly categorize those you encounter as either a "Franz" or a "Beth."

Here's my advice: do whatever you can to hang out with the "Beths" of the world. Their passion for photography combined with their humble desire to honor the clients they're serving is what sets them apart.

Look for these qualities to see if you (or someone you know) is a Beth or a Franz:

"Beth" Characteristics

- » Client-centered
- » Always learning; a perennial "amateur" (more on this excellent quality later)
- » Service-minded
- » Humble, not driven by ego
- » Personable
- » Adaptable, willing to change with a changing world
- » Flexible
- » Open to new technology
- » Able to delegate and outsource

Franz (Grumpy) Characteristics

- » Self-centered
- » Knows everything, sees himself as an expert
- » Feels entitled to business
- » Always asks first, "What's in it for me?"
- » Arrogant

» Complaining

» Attitude of "I'm doing you a favor"

» Stuck in old business models

» Rigid

» Sees new technology as a threat

» Controlling, feels a need to do everything himself

All of the above characteristics are critical, but perhaps the one that most vitally distinguishes the optimistic, successful photographer from the resentful, ineffectual one is adaptability. We live in changing times and there are really only two responses: learn to ride the wave or be drowned by it. If you insist on clinging to old models, old expectations and old knowledge, you will drown.

The State of Our Age: Globalization and Photography

We live at an intriguing cusp in history. The world is in the midst of dramatic change and no one really knows for sure where it's headed. I suggested earlier that I want to offer you a roadmap for success. That's not quite an accurate metaphor. I don't want to give you a map, I want you to become a trailblazer. That is, I want to help you learn how to chart your own course through unknown terrain. I want to give you the tools not to do what you're told but to adapt to a world in flux, leveraging your uniqueness intelligently.

So, as we continue in this conversation about how to navigate your path in photography, we need to talk about the unique age we live in.

As *The World is Flat* author Thomas Friedman has persuasively pointed out, the world is indeed flat. What he means is that the old rules of how we engage the marketplace have changed. And by "changed," he does not mean, "adjusted." We're talking caterpillar-to-butterfly metamorphosis.

We happen to be living in one of those rare moments in history where the rules of engagement are being re-written right before our eyes. The trouble is, very few people are aware of the new rulebook. And those who are playing by the old one are destined for confusion, pain and failure.

What does a "flat world" mean? Essentially it means that where there used to be a hierarchy of power, there is now a level playing field. IBM now competes with fifteen-year-olds from Romania; a great idea scribbled on a napkin can become a multi-million dollar enterprise practically overnight; and business icons who rose to power over decades of labor can fall from grace in the blink of an eye.

Most important to our conversation, though: all service industries are now in the midst of fierce global competition in ways never before imaginable. Most professionals in these industries, however, are still living their business lives as though their only competition existed in their local phone book.

If you're considering joining the wedding photography industry, it's tempting to believe that it's not possible for people in India or China to take your business away. And, in a sense, that's true. A photographer living in China is probably not going to shoot your weddings. However, the new world is vastly more complex than that.

Offshore competitors may not take your gigs away, but there are parts of your future job as a photographer that they will and should take away. A few examples that immediately come to mind include:

» Lead tracking

» Web design

» Color correcting

» RAW image conversion

» Categorizing images

» Uploading images

» Print making

» Album design

» Order fulfillment

» Accounting and tax preparation

Your future success as a professional photographer will be in direct proportion to your ability to know which parts of the job to keep and which parts to share with those creative partners you employ on the other side of town and the other side of the globe.

And here's the main point: your ultimate goal is to personally perform only those aspects of the job that are most central to who you are as photographer and to outsource the rest. If increasing scarcity does indeed increase value, then your job is to build a business that is as "scarce" and uniquely "you" as possible. Your core business should focus, to the largest extent possible, on things that you, and only you, bring to the table.

The new rule of thumb becomes this: anything "generic" that you do as part of your business, try to outsource it. Anything uniquely "you," build on it.

If you want to thrive as a photographer, the flat world is very good news. Because it not only allows you to be creative and unique, it now demands it.

The Digi-Flat Era

Everyone knows that the digital revolution is now complete. What was once revolutionary has become the status quo. Such is the nature of revolutions. With this regime change came shifts in how the industry works. These shifts are neither good nor bad, they just are. For example, more powerful digital equipment now shortens the learning curve for

newcomers, lowering the perceived risk of getting into the industry. Another example is that the decreasing cost of technology has resulted in a boom in the sale of professional-quality DSLRs, putting the tools of the trade in more hands.

There are more changes I'll address as the book unfolds, but those two examples alone have opened up dramatic new possibilities never available before. You really can choose your own photographic adventure. That's why the ideas in this book are so important. They're not about telling you what to do. They're about opening up your thinking to new and doable possibilities so that you can forge a liberating career in one of the coolest industries in history.

I believe labeling our current era "digital" is dramatically shortsighted. There is so much more going on than a digital revolution. And if we don't understand our times more comprehensively, we will miss the big picture (pardon the pun). And it's the big picture that holds both our greatest opportunity and our greatest threat. The truth is that anyone in a service-based industry who employs outdated rules for how to engage the marketplace will not survive much longer.

One of the reasons it's so tough to wrap our minds around what I'm describing, especially if you've been around photography for a while, is that our industry has already undergone so much dramatic change recently. The rise of digital technology and the fall of film was such a gargantuan shift—and it happened so quickly—it would be nice to believe we've had our fill of transition for a while. Shouldn't we be allowed to relax for a minute and enjoy the digital era?

The answer is no, at least if you intend to avoid extinction and to thrive as a professional photographer.

For many of my colleagues who've been around much longer than I, the digital revolution felt like a massive earthquake. In light of what's to come, though, I believe we'll view it as little more than a technological

milestone in the history of photography. We are now on the front end of a far more powerful change, a Perfect Storm that is gathering force as digital technology meets the flattened world. This change will dwarf the shifts endured when photography went digital.

I want to name and claim this new day for the photography industry (and for nearly every other industry as well). I'm calling it the Digi-Flat Era.

We Live on Krypton

The era we live in reminds me of the last days of the planet Krypton.

Remember Superman? When he was just a little baby he lived with his real parents on his home planet far, far from Earth. Times were dire but no one was paying attention. Only his folks appreciated the reality of what they were in the midst of.

The world as they knew it was going to blow up (literally) but everyone around them was happily ignoring the signs. They acknowledged that things were changing, but refused to embrace the reality of their circumstances. And the consequences of that misstep were tragic.

But not for Superman. Because his family made the right move by sending him to planet Earth. And because of that decisive choice, young Superman quickly found himself in a whole new world. After some adjustments, he came to realize that he possessed a remarkable characteristic: he had developed Super-Strength, the likes of which he never could have enjoyed on his home planet. If he had stayed on Krypton, he would have been just another kid about to be blown up. By going bravely to the new world he became a Super.

But he wasn't the only one to leave Krypton. Several bad guys made it out as well. And they had Super-powers too. The crazy thing is they didn't do anything special to get these powers. Like Superman, they became Super just by adapting to their circumstances. It wasn't a Good vs. Evil thing; it was just a matter of adaptation.

By putting themselves in the right place at the right time, in the right way, they opened the door to powers that were far beyond what they could have ever accomplished in the old world. In a sense, they were Fast Track Super-heroes and Fast Track Super-villains. What's noteworthy is just how fast it all happened.

My aim is to make you a Fast Track Wedding Photographer hero. How? First of all, by challenging you to never let your thinking get stale. Always stay nimble and quick on your feet. Never fall into the trap of believing that the "rules" you learn today will still apply tomorrow. Always be looking around the corner for the next new development in business, technology and society that will create needs and opportunities you can address through your business.

Just consider, for a moment, a few of these recent developments of the Digi-Flat Era:

» The ability to remotely exchange photos has never been easier. Laptops, PDAs, and cell phones have become photo-exchanging devices. Cameras themselves can now send and receive photos.

» Printers are getting faster, better, smaller and cheaper every year.

» Photoshop allows average users to alter and create images in photorealistic detail, both from their desktops and, now, online.

» Social networking sites like MySpace and Facebook dominate the leisure life of people under 25 and consume a constant flood of photographic images.

» Software now allows users to easily assemble and design photo albums of various types.

» Digital photo displays are getting cheaper and proliferating everywhere. Key chains, photo frames, even greeting cards can now download and display custom digital images.

» Sites like YouTube (and the photographer-centric Cut Frame TV)

have thoroughly "democratized" the shooting and distributing of video images.

» Blockbuster, which began only a few years ago as a brick-and-mortar videotape rental store, has now, along with Netflix, mechanized and streamlined the exchange of DVDs by mail. Soon all movie content will be delivered online, eliminating the need for both the storage medium (DVDs) and the store.

» Monthly membership fees have become a common method of paying for digital services and commodities.

» Wireless Internet is becoming more and more universal and can be accessed by ever cheaper devices such as cell phones. Soon almost any type of content will be able to stream, in real time, to almost any electronic device.

» Television is quickly becoming more interactive and will soon include all the features of a personal computer, but adapted for the "living room" user. Mainstream advertising will soon become interactive, collecting and sending customized information to customized consumer lists.

As you think about each of the above developments, do you see any old doors that will be closing soon? For each old door that closes, can you imagine what new ones might open in its place?

"The Words of the Prophet Are Written on the Subway Walls"

When Paul Simon and Art Garfunkel sang those words in the 1960s, they spoke for a generation tired of listening to the establishment tell them how to live their lives. They seemed to be inviting their listeners to look for the true prophecies emerging all around them and not to seek answers from the old guard.

We face a similar scenario today in the photography industry. Of course,

it would be foolish for any newcomer not to learn from those who've gone before them. There is a foundation in photography that is common to every generation. Good composition is good composition. Yet, it is also true that the circumstances facing new shooters are in many ways unprecedented and thus need new methods to navigate. There are things that can only be learned by this generation.

The old mode of learning from an expert and slogging away until you've earned the right to put your name out there is too slow for our fast-changing, Digi-Flat times. It's not that you shouldn't work with or for more seasoned professionals at the beginning of your career. That could very well be a wise move, depending on how you learn and what motivates you. But to trust your development to anyone else is not wise. Famed screenwriter William Goldman once said of the film industry, "No one knows anything." (If they did, he pointed out, then everyone would be cranking out mega-hit movies, one after another.)

The same can be said of the state of the photographic world today. No one knows anything. No one is an expert, because no one really knows what new developments will occur in the next five, ten, or twenty years and how these new developments might interact dynamically to create whole new possibilities.

Your vision, your roadmap, your inventive ideas are just as valid as anyone else's. I urge you to claim that right.

Take responsibility for your professional growth. You don't have time to wait. The world's flattened condition has forced us all to expedite our learning curves. It used to be you had to learn from a pro before you could become a pro. Now you have to learn from the pros while you're becoming a pro. You need to "be" and "become" at the same time. That is: achieve a base level of competence in your craft as quickly as possible, then start finding ways to enter the professional marketplace ASAP, improving and developing as you go. Otherwise, you will be left in the dust of those charging up the road ahead of you.

I believe that how you define what it means to be a professional will set the limits on how far you can take your photographic career. Your definition of professional establishes the ultimate end of what you're hoping to achieve and how you're going to accomplish it.

Starting Off Right

In the era that's quickly vanishing in our rear-view mirror, most of us defined professionalism based largely on time—how much time you spent paying your dues (historical time) and how much time you currently spend working as a professional shooter (present time). Time was the defining element, and time used to be a reasonable measuring stick. But it isn't anymore. Again, learning curves have flattened, due to new camera technology, new software and new learning opportunities, among other things. It doesn't take as long to go pro as it used to.

I would argue that a more relevant definition of a professional photographer should be grounded in (1) what you produce and (2) how you profit. Because of the Digi-Flat times we live in, both production and profit can occur more quickly. "Paying dues" and logging hours no longer have the value they once did. Time should not be your measuring stick of professionalism. And this is tremendously good news for those of you who are short on time. It means you can be a pro in five hours a week, if that's the time you have available.

I invite you to begin using what you intend to produce and how you intend to profit as working measuring sticks for your progress as a photographer. Get straight on those two things and you'll know where you're headed. Stay confused on what it means to be a professional and you won't know where you're going or when and if you get there.

Learning How to Dance

Living in the tension of both being and becoming a professional can cause some feelings of anxiety. You might naturally feel, for example, that

it's dishonest to assert yourself as a pro before you've ever shot an event. If that describes you, then I encourage you to honor your instincts and not to say it to anyone. That is, don't say it with words. But you can still practice acting like a professional. Then, as others begin noticing you steadily taking ground, they won't discount your presence in the marketplace. You'll have behaved like a pro, so you'll be accepted as one.

Again, I'm not suggesting you "fake it till you make it." Absolutely not. I'm simply saying that you should not create obstacles to your career before it even gets going. If you keep production and profit (however you measure those two things) front and center in your mind, you'll already be far ahead of many seasoned "pros."

Bottom line: given our times and the state of our industry, it's critical that you act like a professional regardless of what people say about you or what you say about yourself.

For a picture of what this might look like, turn to Chapter Two. I've got a true story that will blow your mind and jumpstart your imagination as to what's possible in a very short period of time. Read on!

CHAPTER TWO

The Power of Choosing Your Own Adventure

A Star is Born

Jasmine De La Torre was one of the most attractive brides I'd ever seen. I first became aware of her when her wedding photographer, David Jay, displayed a handful of images from her Hawaiian wedding on Pictage's community forum. One particular image stood out: Jasmine and her new husband, JD, standing on a jetty with her dress flowing out over ocean and sky. That photo eventually found its way onto the cover of *Professional Photographer Magazine*. What was remarkable, though, wasn't Jasmine's beauty or the fact that she made the cover of a national photography magazine. It was what she did next.

Inspired by David Jay's ability and business model, Jasmine was bitten by the photographer bug. Like many before her (including this author) the former UCLA law student caught a vision for the possibilities that might unfold for her if she adapted David's "freedom-based" business model to her own life. What was less common, however, was the speed with which she did it.

After experiencing life on the other side of the lens, she leveraged her winsome presence and fun persona by connecting with many of David's colleagues on forums, at tradeshows and at parties. Jasmine was always willing to help anyone she could, in exchange for getting to know that person. She put herself in a *serving and learning* posture and collected insight, acumen and a growing list of contacts in the process.

A few months later, she decided she wanted to become a serious photographer and bought her first professional DSLR. Wasting no time, she put everything she had learned from the photo community to work. In the words of *The 4-Hour Workweek* author Timothy Ferriss, she made her DEAL: she *Defined* what she wanted to be about, *Eliminated* what was going to get in her way, *Automated* all aspects of her work that didn't require her personal touch and through it all she *Liberated* her life. In less than eleven months after purchasing her first camera, the

freshly minted *Jasmine Star* (leveraging her auspicious middle name) launched her website and blog, booked over 35 weddings (raising prices along the way) and was named "Photographer of the Year" by BluDomain's BluBlog. A better title may have been "Photographer of the Year *in Less than a Year*." Now Jasmine is a household name in the wedding photography world. She has become the ultimate rising star.

How did Jasmine do it? Was it her charming personality and good looks that catapulted her career? Those factors certainly didn't hurt. But I would argue it wasn't just that she had an attractive brand to market. Or that she was a gifted artist who unlocked her innate talent. It was that she *designed* her business brand intelligently, at a time that was especially hospitable to rapid growth and worldwide reach.

Flat = Opportunity

As worldwide connectivity becomes more streamlined via the Internet, any service that doesn't require a physical presence can be and *is being* outsourced. The future of service-based industries—from law to accounting to photography—is in serious trouble if those industries fail to differentiate their offerings. As the world continues to flatten, players who make their business about *what they produce* (rather than who they are uniquely) are becoming mere commodities in the eyes of consumers.

It's tempting to try to make a ruling on how good or bad this flattening phenomenon will be for our photography world. But I don't think labeling it good or bad is ultimately helpful. Let's just save ourselves the grief and declare that it's both fantastic and tragic, depending on how you react to it. As an industry, photography hasn't become better or worse. All that's changed are the rules of engagement.

Consider Jasmine Star. It was precisely because of our Digi-Flat times that she was able to take the ground she did so quickly. But hers was no get-rich scheme. Jasmine made her moves in a hyper-competitive

marketplace at a time when many thousands of inspired enthusiasts were trying to do the same thing. Yet, her journey to success occurred at warp speed. As other very talented shooters struggled to get noticed, drowning in a sea of cutthroat, generic and commodity-based competition, Jasmine seemed to bullet-train her way to the front of the line.

"That's fine and good for the talented, gorgeous and well-connected Jasmine Star," you might be thinking. "For us mere mortals, that kind of success just isn't available." Yet countless less blessed photographers have successfully leveraged our times along with Jasmine. Many of them have gone the Signature Brand Photographer route, as Jasmine did, establishing public names and personalities for themselves. But many others have been able to turn their recently acquired cameras into revenue-producing machines by exploring the Freelance Photographer option as well.

It all depends on who you are, what you want and what you bring to the table.

A New Era in Wedding Photography

The Digi-Flat world offers Freelance Photographers new options that weren't available only a few years ago, thanks in part to companies like Bella Pictures. Even as I type the name, I know that it will invite strong reactions from many readers. Why? Well, Bella is a large and growing company, with offices in several major U.S. cities that some photographers see as a threat. It has systematized, streamlined, and some would say "corporatized" the entire wedding photography process. Bella books numerous events, nationwide, then contracts with freelance photographers to shoot them. For some, this type of company represents a welcome new opportunity for freelance work. For others it represents a corporate "evil empire" of sorts. And so, Bella has been met with relief, excitement and dramatic criticism.

Bella's corporate business model is eminently adapted to a Digi-Flat world. From the start, it began recruiting talented shooters who were tired of the laborious chores of sales, marketing and post-production. For some this opportunity was a godsend. For others it was perceived as a threat to their viability as a boutique "mom and pop" shop. On forums all over the Internet, Bella was portrayed as the ultimate enemy, "stealing" business from the little guys.

Bella *has* been incredibly successful, booking and shooting hundreds of weddings and events every weekend. They've also grown 2.5 times each year they've been in business. But I honestly don't think they are out to hurt true Signature Brand boutiques. Their success has come about because their business model is in line with our Digi-Flat times. The fee-based model of wedding photography *had* to happen. It was inevitable. And those who adjust to the market will in time recognize how positive this development will ultimately be for our industry.

Put in a different way, Bella wasn't the only winner in this new development. For the first time, individuals who got into this business purely because they loved taking pictures (and who had proven talent) were now given a viable means to return to their first love: shooting.

I can't think of another (legal) occupation where in less than a year, a reasonably artistic individual can go out and purchase a machine (i.e., a DSLR) and get hired as an independent contractor, getting paid between $300 and $1000 per day. And this without ever being known as a Signature Brand Photographer. Bella's Freelance shooters are making a killing per hour when you consider how little risk they have on the line.

But doesn't this kind of work focus on the *product* rather than the photographer? Yes, but only partially. You see, Bella (and companies that adopt its model) attempts to customize each job to the unique tastes, budget and design requirements of the client. Part of this customizing process involves selecting the *right photographer* for the client's needs. So a photographer is chosen on the basis of the particular talents, style

and personality she brings to the table for that particular job. One photographer, for example, might excel at elegant, classical weddings, another at casual contemporary. It still comes down, to a large extent, to the *photographer*, even though that photographer may not be directly selling herself as a Signature brand to the bride and groom.

Freelance or Signature Brand?

What are the reasons someone might decide to become a Freelance Photographer as opposed to a Signature Brand Photographer? At bottom, it's a risk/reward thing, as in any other profession that hires contractors. Freelancers limit both their income potential (main drawback) and their risk potential (main benefit). For many, this is a worthwhile trade-off. When you opt to go the Freelance route, the complex costs of establishing yourself as a brand are no longer a concern. Nor are most of the liabilities.

Many photographers have begun to realize that being responsible for every detail of running a photography business in a globally competitive market isn't all it's cracked up to be and are happily pursuing the Freelance route. Even Signature Brand Photographers with free weekends on their hands can now make extra cash by offering their services on a freelance basis. This "extra" work comes without the burdens of self-promotion or of personally connecting with their clients. Again, fee-based companies don't sell name brand photographers. The person who actually takes the pictures is less relevant in this model, at least to the end user. For some shooters, avoiding the spotlight in this way is a welcome relief.

Of course, the obvious upside of being a Signature Brand Photographer is that you have unlimited potential to earn the kind of money you want to make and to design the kind of business you want to run. It all depends, again, on knowing who you are and what you honestly want.

By now you should see the spectrum of possibility widen for you. The existence of fee-based companies has actually added options for professional shooters, not subtracted them. Before such companies existed, contract work was harder to find and much less plentiful. True, you could get occasional gigs as a second shooter for another photographer, but today well-paid "first shooter" opportunities are available, should you be interested.

FREELANCE PHOTOGRAPHER	SIGNATURE BRAND PHOTOGRAPHER
Photography is most important (to the end user)	Photographer is more important (to the end user)
No branding process required	Branding process is required
Employer does all the selling/marketing	You (or your employees) are responsible for marketing, sales and advertising
Employer does the initial and follow-up customer interactions	You (or your employees) handle all customer interactions
Employer establishes the system and protocols to follow	You are required to establish your own systems and protocols
Income is limited to an agreed-upon fee	You have unlimited income potential (via scalability and/or higher fees that in-demand Signature Brand Photographers can charge)
Employer assumes most liabilities	You have ultimate liability
Lower risk	Higher risk

The above chart shows some of the key differences between working as a Freelance and a Signature Brand Photographer. It doesn't end there, though. The two poles open up a myriad of combinations in between. Discovering your unique fit given your particular personality, strengths, and circumstances ultimately allows you to create a custom job description suited solely to you. For example, those with the personal

and professional qualities to make it long-term as Signature Brand Photographers can now buy themselves time (and pay some bills) by simultaneously working Freelance jobs while they work up their brand identity, portfolio and marketing strategy.

Those committed to other meaningful aspects of life—such as raising children, keeping a primary "day job," volunteer work, or the desire for leisure and freedom—no longer have to sacrifice these things in order to become professional photographers.

Change is Here and It's Neither Good nor Bad

When the fee-based model was introduced to the industry, it was criticized as unfair competition to branded boutiques. This was a shortsighted response. It should also have been characterized as a ratchet that created dramatic new opportunities. Now more people than ever get to play. And those who were already playing are forced to raise their game. In the end, everyone who *should* be in the industry wins. The only folks who lose are those who lack the fundamental talents and/or fail to commit to their unique fit within the industry.

What's amazing to me isn't that so much change is occurring in the wedding photography industry, it's that so few people are awake to it. These changes shouldn't be surprising or difficult to grasp. After all, standardization is happening in every service-based industry in the Digi-Flat era. The writing is on the proverbial wall. You don't get to choose whether change is coming or not, but you do get to decide whether you want to ride the wave and thrive…or get Grumpy about it and perish.

Ultimately, the clients who hire us benefit the most from all these shifts. For those who value the photography primarily, they now have fee-based companies like Bella to hire. For those desiring a trusting relationship with the professional who will be capturing their precious memories, Signature Brand Photographers are waiting in the wings.

And there's no shortage of work. More people than ever want their pictures taken professionally! Given our culture's high demand for memorializing meaningful events (not just weddings), this trend will no doubt translate into a lot of work for a lot of people as long as they avoid the one common enemy: becoming a commodity.

Whether you are a Signature Brand Photographer or a Freelance Photographer, you must remember to be personally and professionally distinct in order to avoid extinction. Your distinct eye, your distinct talents, your distinct personality are the values you bring to the marketplace, regardless of which route you choose as a professional. True, your "you-ness" is valued in a more primary way within the Signature Brand Photographer arena, but it still counts for a great deal even if you choose to go the Freelance route. Again, the reason you will be selected over another photographer for any particular job—whether by a client or by a fee-based employer—comes down to who you are and what you bring to the table.

The New Market—Where Do You Fit?

The reason Bella is doing so well is because it has established the baseline for what a bride and groom ought to expect, at a national average price point. What Starbucks did for coffee, Bella is doing for photography. The whole industry's bar has been raised, with Bella establishing the lowest common denominator. If you want to compete for that market share, you need to know that Bella is the standard you have to beat. Or, if you can't beat 'em, join 'em. It's still your choice.

The ultimate value of a fee-based photographer studio like Bella is its ability to recruit and train shooters willing to shoot the Bella way. Again, like Starbucks, it's critical for their clients to feel they're getting output that is consistent. But, because various clients have various needs, budgets and tastes, there is still room for individuality within this structure. Bella couples a particular photographer with a particular event, based on

his/her unique talents. Depending on your DNA as a photographer, the idea of having a company like Bella train and hire you at a minimum of $300 per day might be a pretty appealing option.

On the other hand, you might be up for beating Bella at its own game. Since Bella is national and therefore somewhat generic, why not create a studio that tackles your regional market in a more targeted manner? Why not create a standardized offering that competes with the national average rather than the premium market? If you can establish economies of scale by hiring other shooters and generating a higher volume than most boutique operations, you'll be in great shape. That's what Jim Kennedy of Huntington Beach, California did. In 2007 alone, his small studio of five shooters shot over 300 weddings, offering clients more bang for the buck than most small studios ever could.

Or, of course, you might be best suited to creating a competitive Signature Brand Photographer business instead. Signature Brand shooters don't market their brands based on bang for the buck, because they don't sell photographs per se. They sell their name associated with high-end weddings. Signature Brand Photographers such as Robert Evans, Denis Reggie, Joe Buissink and Mike Colón have been able to command minimum day rates of $20,000–$50,000 for shooting a single celebrity wedding. That's because the brides who hire these superstars know they are buying name brands, which come at a high premium. That exchange brings with it a value that is greater than any number of albums or prints ever could. It also requires the photographer to make a different kind of commitment to their customers and their craft. But if you're clear about what you're selling and whom you're selling to, you're now empowered to do just that.

The only folks who are guaranteed to lose in the new market are those who get caught believing they are living on one side of the continuum when in the minds of the buying public, they are on the other. These folks often talk and act as if they are Signature Brand Photographers, but don't make the requisite commitments to market themselves that

way. They keep their prices low in order to get more jobs and as a result their prospective clients view them as low-end shooters. But since they can't afford to offer anything near what a Jim Kennedy or a Bella do, their value drops again. Then, when presented with the option of going to work for a Kennedy or Bella, pride gets in the way and they fail to avail themselves of the opportunity because, in their own minds, they are Signature Brand shooters. It's a vicious and entirely avoidable spiral.

Rather than lapse into Grumpiness, I encourage you to see that in the Digi-Flat world, the spectrum of possibility has exploded. You can now go the Freelance route, the Signature Brand route, or create some other custom solution in between. Just be clear about what choice you're making and do what's required to see it through. Sadly, too many of my friends are asleep at the wheel and fail to see the fork in the road. The trick is to understand the trade-offs inherent in all of these possibilities. Then, make every effort to understand the optimal approach with which you should engage the industry.

Maximizing one's custom fit within the industry, I'm convinced, will become the new measuring stick for who the leading professionals really are.

The Best in the World

Maximizing your fit means being the best "you" that you can be. As a photographer, if you don't begin to actively work at being the best something in some world, you are not going to succeed for very long. The irony is that despite the flattening effect of modern commerce, it's never been easier to be the best. The Internet, among other new technologies, has given us remarkable tools for targeting very specific markets that have very specific needs and tastes. Whatever talents and personality you have, there's practically guaranteed to be a niche market out there waiting for you to fill it. What's challenging is (1) deciding which category you will be The Best in, and (2) making the tough choices to see that choice come true.

The best news of all is that the clues to the category you were meant to dominate are right under your nose. You just need a little help to take notice. That's one of the main purposes of this book.

Fixing Weakness vs. Maximizing Strength

If you were asked right now how to make the greatest improvements in your life or business, what would your strategy be?

According to the Gallup organization, most people would say to find your weaknesses and cleverly turn them around. Becoming "balanced" and "well-rounded" seem to be universal goals. And so, most people, and most businesses, spend 80 or 90% of their energy identifying and correcting flaws.

But there's a very important point that I want you to understand. Grasping this one idea will do more to guarantee your success than just about any other advice in this book (or in any other business book I can think of). That point is this: if you want to be a success in the Digi-Flat world, you must flip the formula around. You must be prepared to invest at least 80% of your energies in identifying and building on your strengths. The great businesses of this world do not become successful by correcting their flaws. That is an inherently negative and limiting approach. Rather, the great businesses find something they can do better than anyone else and then leverage these strengths to the maximum. They are driven by passion, talent and creative innovation.

Weakness correction, as a business strategy, unconsciously sets a low ceiling on what you can achieve. With strength leveraging, however, the sky's the limit. So if you want to succeed in this new era—if you want to lift your business above the level of replicable commodity—you must find the things you are amazingly good at doing and build, build, build upon them. You can bet that's what the next hugely successful business is doing.

The heart of your business concept should revolve around the things you both love to do and can do better than anyone else. THAT is what you have to offer the world. And if you keep your focus on that, you will find yourself competing in, and dominating, a wonderful market of one.

Although the desire for balance may seem intuitively right to pursue, it turns out not to be a very good strategy if you intend on being a player in these Digi-Flat times. If you want to really succeed, maximizing who you are and what you are uniquely talented at gets you further with less effort than any amount of weakness improvement will ever do.

Does that mean you ignore your weaknesses? Not at all. You must be keenly aware of the skills and assets you lack. Then you must intelligently decide whether to: (1) improve upon them, (2) work around them or (3) delegate/outsource them. But all of this must be done within the context of maximizing your uniqueness, not toeing the line, achieving "balance," or meeting some imaginary standard.

So that's my bias and I wanted to get it on the table: leverage what you're great at, minimize the rest.

The importance of this approach will become even more apparent in the next chapter, as we talk about your pDNA.

The Photographer's Twist

In the world of photography, our perfect storm of Digi-Flat challenges and opportunities is even more potent than that of other service-based industries. Why? One reason is that for most established industries, there is still a *perceived* need for a professional to actually do the work. In law and accounting, for instance, most people believe that the lawyer and the accountant must chase the paper and crunch the numbers. With photography however, many have come to believe (often unconsciously) that the equipment we use does much of the heavy lifting, regardless of who presses the button.

Of course, anyone who has worked in the business knows: a good camera does not a professional photographer make. Witness the sea of bad output by well-equipped "pros." Yet, the perception of universal accessibility remains. Many people believe that if they go out and buy a professional-grade camera, they will get professional-grade images. No one believes this to be true for a lawyer or accountant. Does anyone seriously think that if you bought a professional grade case law book or calculator, you could easily defend someone in court or get your taxes done automatically?

This perception of accessibility presents alluring prospects to the enthusiast photographer and would-be professional. It now appears to many that they have easy access to a world that was previously off limits, simply by purchasing the right equipment.

Shouldn't we all be worried about this? Won't the enthusiast of today become the threat of tomorrow? If the barrier to entry is so low that anyone can become a professional, won't we reach saturation point more quickly? Will there be enough business to go around if every potential pro actualizes that potential?

If you're a practicing professional already, you may be worried that competition will surge like never before. In a sense, you'd be correct. But if you're intentional with your choices, there's no reason this should be a threat.

On the other hand, you may be aspiring to go pro. Let's say that, after you learn and apply the insights from this book, you succeed in that effort. Now let's also say that the trends I'm describing make it even easier for future aspirants to join our ranks. Won't you be left with less opportunity and more competition in the future?

Not necessarily.

What's critical to understand here is that if you know who you are and what your primary business is, failure is virtually impossible regardless

of the level of competition. You need to design your sweet spot as a photographer around the one thing that cannot be replicated: you.

The value you bring to the industry is going to be different for each and every person who's reading this book. But here are a few questions, just to get you cogitating in the right direction:

» Do you inspire confidence in others?

» What subject matter do you have a unique ability to photograph (people, nature, children, events, etc.)?

» Are you gifted at getting people to laugh, relax or converse?

» Does your personality or background allow you to relate to members of certain groups within society or to people from certain locations or professions?

» Are you talented at creating posed pictures that look natural?

» Does your work have a strong spiritual dimension?

» Do you have a unique understanding of visual symbolism?

» Do you have a background in, or understanding of, event planning?

» Do you have extensive knowledge and/or love of classical art?

» Are you theatrically inclined?

» Is your main strength in teaching and inspiring other creative people?

» Are you more psychologically astute than the average photographer?

» Are you a strong visual storyteller with a gift for stringing images together meaningfully?

» Are you an animal lover?

» Do you enjoy creating unusual visual effects?

» Is portraiture a key strength of yours?

» Do you see yourself more as a traditionalist or avant-garde?

» Do you love and excel at post-production?

Embracing Our New Culture

The first step in the process of discovering your unique call as a photographer is this: don't panic. The new shift in the culture of photography is neither bad nor good, it just *is*. That means we can all just relax and thoughtfully orient our perspective. This sea change isn't just true for *wedding* photography. Every medium of digital capture has been affected, leaving old models outdated and new models waiting to be created by those creative and enthusiastic enough to do so. As with continental shifts or global warming, those who soberly and unemotionally adapt to what's next tend to flourish more than those who cling to the past or react out of fear.

Many of you reading this are coming into the industry at the perfect moment. If you embrace our times with an open mind, you will have a dramatic competitive advantage over those who have already settled in their ways. Just remember that the day will come when things will change again. An attitude of staying creatively adaptable may be the single most important asset in extending your lifespan as a photographer indefinitely.

So take a deep breath. The remainder of this book is about how to best fit yourself into the changing landscape of photography today. Rest assured, you do have a unique spot. The fun work now is in finding it. "Photography as commodity" is a phenomenon we all need to adapt our way around. Like gravity, it's best just to take it as it comes and dance with it. There are forces at work—some deliberate, some accidental—that are attempting to turn photography into a consumable product, rather than a very personalized service offered by unique individuals. Knowing and accepting this is the best way to learn how to work around it and profit from it.

The commodity culture is bigger than any of us. Again, think of it as a huge ocean wave. All great surfers understand that if you adapt to the wave—using the best equipment and techniques for the job—you can ride it indefinitely and with great success. Novice surfers get into trouble when they fail to respect the wave and try to surf on their own terms—applying the most familiar, rather than the most appropriate, tools and techniques. This results in the misguided notion that waves are the enemy or that their equipment failed them. In truth, they failed themselves before they even paddled out.

And, of course, there are those who don't even try to surf, but stubbornly hold their ground instead. We know what happens to them.

The tide is indeed shifting in wedding and event photography. How you adapt to it is all that matters.

Choose Your Own Adventure

I suspect many of you started thinking about being a professional because you were inspired by a known photographer. I know when I got into our industry, I had a small circle of celebrity-like photographers that I compared myself to and wanted to emulate.

In retrospect, that wasn't the best strategy to get started with. There were so many more options available to me that I didn't consider, at least not at first.

If you want to find your sweet spot in the photo world, I urge you to resist the temptation to emulate heroes. Most likely the individuals you admire are flourishing precisely because they are engaging the industry in a very customized fashion. Unless you are just like them, the odds of succeeding by adopting their strategies is very low. Better to let them inspire you by how boldly they pursue their unique spot in the business. As you begin to get clearer on what's available to you, you'll see that you have far more options available to you than even your greatest heroes have put on display.

From Being Controlled to Being in Control

I hope by now you're getting my point. If you are making your business about something you cannot control (i.e. photography itself, which, as a product, is defined by the culture and not by you), you will not be able to define your destiny. Of course, you *will* need to learn how to take good photographs—that goes without saying—but far beyond this, you'll need to personally design your approach to the industry.

The road to *designing* your Photo Self begins with *understanding* your Real Self. The next chapter and the accompanying *Photographer DNA (pDNA) Assessment Tool* will be the keys to helping you do just that.

CHAPTER THREE
Photographer by Design

Don't Just Invent Yourself, *Design* Yourself

When Steve Jobs announced to the world that Apple had created a machine to play MP3 files that was going to change how the world would listen to music, he wasn't kidding. The iPod phenomenon has spawned an entire industry. And it certainly didn't happen by accident. The iPod took over the premium music player market because it accomplished three very important goals: (1) it was remarkably functional, (2) it was packaged in a stunningly elegant way, and (3) it was a premium product with premium value that was immediately recognizable to the masses.

The iPod straddled function and fashion seamlessly and created a new category of personal entertainment in the form of a device that has maintained a stranglehold on the very industry it created. From its clever click wheel to its signature white headphones, the iPod is both a music machine and a cultural phenomenon. The iPod marches on, unrivaled.

How did Apple do it? What was their magic formula? Well, as with all world-dominant designs, the magic behind it isn't as elusive as it appears.

When inventors create something new, they all begin with the same basic need: to solve a real problem. Nothing new there. At a basic level, inventing is simply the act of creating clever solutions to needs. The great inventors don't stop there, though. They design solutions that not only solve functional problems but do so with grace and style. They not only solve a problem, they make a statement. Examples abound. From Aeron chairs to Dyson vacuums, these objects of function, beauty and desirability start by addressing a functional problem and finish as works of art.

Solving functional problems is certainly a worthy challenge. But if the goal is to create something extraordinary (i.e., the best in the world), more than function must be addressed. In the grand scheme of things, solving problems is relatively easy to do. The ability for humans to create new ways to get stuff done is endless. But a great product is about more than getting stuff done. So is a great business.

So, it would be shortsighted to address your business exclusively as a problem that needs solving. There are certain micro-problems we'll address as we tease out the details of your design. But let's get clear on one thing: you are much more than a problem to be solved. You are a design to be discovered. My desire is to help you drill for your unique potential and actualize it in the most elegant way imaginable in the real world.

I want you to become the iPod of your corner of the photography world.

Being You-nique

To succeed at becoming the best in the world, you need to have a clear and ever-deepening understanding of yourself. The idea of "becoming the best you you can be" can sound trite, but it also happens to be a crucial goal. The first order of business in becoming your best you is discovering who that "you" really is. By finding your You-nique call in life in general and then as a photographer in particular, you will be acquiring the single most important key to discovering the world you were meant to reign over.

Let me make what may sound to some like a controversial statement (though it really isn't): each of us comes to this good green planet with a unique blueprint that has never been, and never will be, precisely replicated. I'm not making a metaphysical statement here. As to how we acquired this pattern or by what or by whom it was created, I have my own convictions but for the sake of this conversation, I will sidestep them for now. I'm just stating the obvious: whether by DNA or destiny and/or divine intervention, each human being on earth lays claim, by birthright, to an entirely distinct make-up. Each of us is uniquely equipped to serve the world, serve our industry, and serve ourselves in ways that no one else can duplicate. So before you plunge into discovering your photographer's DNA, it makes sense to spend at least a few minutes exploring the big picture of who you are.

We don't live in a particularly introspective or philosophical world, despite the glut of self-help books that seem to dominate our bookstore shelves. No, in fact, I've observed that it's quite possible to make it through childhood, adolescence and the better part of adulthood without ever stopping to ask some of life's big questions. For some reason, we just keep dodging them! But because I believe that who we are as photographers must flow from who we are as human beings, I will beg your indulgence for a moment and ask you to ponder a few big questions.

If the following section holds no appeal to you, feel free to skip it. But if you're game, I encourage to do a little soul-searching. Surely these questions deserve greater time and attention than we can give them here, but I don't want to skip over them entirely.

1) Who are you? What are your beliefs about human life? The universe? Do you believe life has meaning? Do you think human life has a purpose? What do you believe is the purpose of your life in particular? Do you think you have important work to accomplish in this lifetime? Do you think it matters? Do you believe you have something to offer the world?

2) What do you value? What do you see as the most important things in life? What are the principles you want to live your life by? What do you cherish, even if you can't explain it to anyone else? How do you define a good life? What are the values a good business should exhibit?

3) What do you want? What are your life's goals? What do you really desire out of life (as distinct from your spouse, your teachers, your peers)? What do you really want when no one else is looking? What do you honestly think will make you happy? What do you crave? What do you fantasize about? What do you want to accomplish in life? How important is income to you? Living in the right place? Doing what you love for a living? What is your personal definition of success? Are you working toward your concept of success right now? If not, why not?

4) What makes you tick? What drives you? What gets you out of bed in the morning? What kinds of situations motivate you to jump in and participate? To excel? What kinds of situations do you find de-motivating or demoralizing? What are you working for? What would you say is your prime drive in life? What are the basic traits or qualities that describe you, good and bad?

5) What are you good at? What are your greatest assets as you see them? Your most unique gifts and talents? What do you have to offer the world? What kinds of tasks or activities cause you to lose track of time and place? Are you ever "in the zone" or in a state of "flow"? What activities take you there? What things do you do that frequently generate praise from others? What would others describe as your greatest strengths?

6) What would you like your legacy to be? What do you want to leave behind you? Are you working on it now? If not, are you ready to get started today?

When you've given these questions at least a little thought, let's move on to discovering your you-nique and powerful particularity within the world of photography.

The Photographer DNA (pDNA) Assessment Tool

I now want to introduce you to a tool called the *Photographer DNA Assessment Tool*—I use the term *pDNA* for short. It's an online, interactive mechanism that will set the table for you to go through three methodical steps for winning as a professional photographer. Each of these three steps correlates with the DNA acronym.

D is for Discovery.

"D" represents the *Discovery* phase. The primary purpose of the pDNA is to help you articulate who you are right now as a photographer. If

you are like me, it is tempting to skip the foundational stuff and dive right into implementation as quickly as possible. This would be a critical mistake. If you don't begin with an accurate picture of who you are, without judgment or pretense, the rest of your planning and intending will have no true foundation. You are where you are right now, whether you like it or not. To deny reality is to live in fantasy.

The good news is that you can change the things you really don't like. The Discovery phase is nothing more than your starting point. But be ruthless in the honesty of your assessment. Discovery is not the stage where you dream of what you *could* be. That comes a little later. For now, you want to reflect only on what *is*. In time you'll recognize this as the greatest foundation you could possibly begin with.

I've tried to make the process easy for you. The pDNA Assessment Tool is all you really need to get started.

N is for Negotiation.

The second stage is the *Negotiation* phase. If you've done a good job with Discovery (which I hope the pDNA test helps you with), here's where you get to benefit from all that self-examination. In the first half of the Negotiation phase, you will be invited to dream through what you *could be* as a photographer if you had no limits or obstacles. You'll identify people, styles and aspects of a professional photo career that you are most attracted to, regardless of whether you think this will become a reality.

The second half of Negotiation will be to weigh your dreams against your present reality. In the process your vision will be refined. By the end, you'll be very clear (and I suspect highly motivated) about whether you want to make this new vision your reality.

Now, with an accurate snapshot of where you're at now and a dream of where you could be in the future, you will enter the Activation stage.

A is for Activation.

"A" stands for *Activation:* getting you from here to there. To transform your dreams from wishful thinking to a lived experience requires a game plan. As you do the "A" step, you'll be taking new ground and fulfilling your destiny as photographer. How cool is that?

Go Take the Test

The rest of this chapter is written to help you interpret your pDNA results, which, in essence, will carry you through the Discovery phase. If you'd like to keep reading ahead right now, no problem; it's your book. You'll get the most out of this chapter, though, if you stop at this point and go take your pDNA. So, if you're game, go do that now.

If you've purchased this book, the pDNA test is free for you. If not or if you'd like to invite someone else to take the test at the same time as you, tests can be purchased by going to http://pdna.fasttrackphotographer. com right now.

Once you've got your results, you can continue on with this chapter. You'll also be able to go online to http://forums.fasttrackphotographer. com and connect with other photographers who have pDNA profiles similar to yours. This is also a fun way to connect and build community. What may be even cooler, though, is that you'll also be able to network with photographers who have dramatically different pDNA results. This will be critical in the future when you realize that there are parts to your workflow you'll always want to personally perform and other parts that you will never want to touch again as long as you live. Believe it or not, there are some amazing people out there who love to do exactly the things you hate. Wouldn't it be great if they were your friends?

Are you beginning to hear the drumbeat for revolution? Soon you'll have the foundation for doing photography as you were meant to do it. Soon you'll be collaborating with other professionals who will propel

your "power of the few" network into the stratosphere.

So, please bookmark this page and go take that pDNA test now. We'll see you back here in a bit.

Welcome Back!

How are you feeling right now? Limited? Liberated? Either way, you now have the building blocks to begin transforming yourself into the optimal you for the photography world. Remember, your pDNA is only a snapshot of where you stand today as a photographer. It does not define your future. It only determines which entrance ramp you start your journey from. Now let's take a peek behind the curtain and develop a working understanding of what is being measured and how you can take the best advantage of this new information.

Discovery

The Discovery phase takes into consideration 14 key factors that I have determined are critical in assessing where you're at and who you are as a photographer. These characteristics include:

pDNA CATEGORY	pDNA DEFINITION
Experience	the degree of experience you have with photography
Self-Starter	the degree to which you start things on your own
Program-Starter	the degree to which your motivation to start things requires an outside program
Confidence	the degree to which you feel confident as a photographer
Risk Tolerance	the degree to which you feel comfortable taking risks
Need for Control	the degree to which you need control to feel strong as a photographer

pDNA CATEGORY	pDNA DEFINITION
Need for Collaboration	the degree to which you need to work with others to feel strong as a photographer
Artistic Identity	the degree to which you find your core identity as a photographer in your artistic expression
Entrepreneurial Identity	the degree to which you find your core identity as a photographer in your success as a businessperson
Attractiveness	the degree to which you draw others to you
Grumpy Factor	the degree to which you measure your success relative to how others are doing (e.g., if others are flourishing, you feel like you're failing; if others are struggling, you feel like you're gaining ground)
Creativity from People	the degree to which you get your creativity from being with people
Creativity from Self	the degree to which you get your creativity from being alone
Self-Promotion	the degree to which you feel comfortable promoting your brand (yourself) and actively seeking new business

Your personal pDNA results gave you a rating of Low, Medium or High for each of the 14 characteristics. Keep in mind that Low does not equal Bad and High does not equal Good. It's important to understand this if you wish to learn from the test. Also, this feedback is just a snapshot of who you are today. Nothing more, nothing less. If you take the test again in the future (and I recommend you do it at least once a year), the Discovery phase should reveal your evolution over time.

So What's Next?

With your pDNA in hand, you now have a basic working knowledge of your probable tendencies as a professional photographer. Think of it as your "photographer's personality profile." It's what you're made of in a

photographic kind of way. These results should empower your choices, not constrict them.

No particular goals need be deduced from the findings—at least not yet. You may be feeling frustrated that you scored low in some category or high in another. Fret not. Again, the results are not good or bad, right or wrong. They just are. And, with that knowledge of what is, you now have tremendous power and opportunity for change.

As I mentioned earlier, many new photographers attempt to speed their progress as professionals by trying to emulate successful shooters in the industry. It's certainly an understandable strategy. But by now, I suspect, you're beginning to see why this can turn out to be pretty discouraging.

Don't get me wrong. I'm a big fan of going to workshops and learning from the best. But doing so with the aim of aping what these folks have done is simply misguided. Why? Because you are not them! Unless their pDNA is very close to yours, it is highly unlikely that you'll ever succeed by trying to do it their way.

On the other hand, imagine if you could attend workshops and seminars armed with a deep understanding of who you really are as a photographer. You could then place the valuable input from the workshop in a context that is incredibly meaningful. That context is you! Equipped with self-knowledge, you'd be able to filter the expert's content through your grid, clinging to the insights that are most relevant to you and letting others pass by. Let me give you an example.

Let's say you attend a workshop by well-known wedding photographer Mike Colón. And, let's say that Mike has a remarkably HIGH Risk Tolerance Quotient as revealed by his pDNA results. In the course of his workshop, he shares a story about the risks he took in his early days that catapulted his career. And now let's say that you have a very LOW Risk Tolerance Quotient. Do you see where I'm going? It would be absolute madness for you to take Mike's experience and try to apply it in your own life.

However, what if you heard Mike's story and were inspired by what he did but trusted your own distinct strengths? What if, as a result, you chose a strategy similar to Mike's, but one that moved at a slower pace? Do you think that might result in a stronger outcome for you? Of course it would. It's true that you may not rise to fame at the pace that Mike Colón did, but you'll probably be around for the long haul to find out.

In honoring your unique pDNA, you set yourself up to live out your unique success in your own unique way.

The Power of the Fast Track System

This book is all about you, not me. Getting clear on the brand you were made to create is the revolutionary aspect of Fast Track Photographer. The pDNA test is simply a tool to help you locate where on the spectrum of professional photography possibilities you are starting from (or continuing from).

You begin with where you are now as a plot point and then you add where you want to go as a future plot point. The trajectory in between is what I and the community you're joining will help you navigate very quickly—faster, I believe, than you could on your own.

The Fast Track doesn't prematurely bog down in details about photography technique. There are so many fine resources out there that deal with the technical aspects of shooting, it would be foolish to replicate that information here. But after applying the Fast Track approach to your own life, you should be better equipped to understand when to leverage those fine resources and when to try something different. Fast Track is not about learning all the controls of the space shuttle, so to speak, it's about becoming the astronaut you were designed to be. Once you know that, you'll know which controls to master and how you can best serve in the shuttle crew.

The next chapter is a bit of an intermission to encourage you to let your pDNA results sink in. To help you do that I thought I would share a little of my own Fast Track story and how these ideas have impacted my own growth in the industry. Then, in Chapter Five, we'll jump right back to your story and take the insights you've gained so far and translate them into a prescription for flourishing beyond measure.

CHAPTER FOUR
"True Confessions"

The Fraud

I was about eight months into my new career in wedding photography. My primary job at the time was as a professor at a small liberal arts college in Santa Barbara, California. I taught Leadership and Character Development and one of my students had become my photo mentor. At the time, David Jay was relatively unknown to the wedding photography world but the writing was already on the wall: he was destined for greatness.

Less than two years into his own career, David's talent as a photographer and intuitive entrepreneur were already beginning to bear fruit. He was an absolute natural. I, on the other hand, was simply an enthusiastic amateur. Thankfully, enthusiasm covered a lot of my sins but I still bore a serious handicap. My handicap was that I was thoroughly enamored with what David was up to. And I wasn't alone. For many of us watching, DJ was the Kobe Bryant of the photo world. I couldn't help comparing myself to him.

To give you some context, my wife and I had recently moved to the area with our only son. I was in my early thirties and before this time would have classified myself as "non-creative." Almost by chance I had stumbled onto an art form that captured my passion. When I began taking black and white film pictures with my "Andre Agassi endorsed" Canon Rebel and people started saying nice things about my work, I was crazy enough to believe them. What did I know? Only that I liked electronics and I liked it when people said nice things. That was enough to keep me moving forward.

I was also fascinated with the magical power that came with taking pictures. I've always admired those who could illustrate with paint or pencil. When I read an interview with the late, great Henri Cartier-Bresson, the master photographer described taking pictures as "expedited drawing." When I read that phrase, it clicked for me: Maybe if

I bought a really expensive camera, I might find my free ticket to skip all that hard work that regular artists had to deal with. Of course, I was wrong. But I was no less motivated.

David was on an entirely different track. Even in his early twenties, he was a rock star photographer. With charm, looks, personality and as shrewd a business mind as I had ever known, he had leveraged his talent to create something of a cult following. Everyone loved David Jay.

Second shooting a wedding with him was like being Justin Timberlake's sidekick. Brides who just married someone else would gush at his presence. Mothers and aunts would swoon. Even the fellas would gasp when he turned on his reception slideshows. The guy had the goods.

With a few film and Photoshop classes under my belt and my new digital SLR in hand, I had assisted David a few times and had only shot a few weddings on my own.

Knowing very little, I came to the conclusion that what David was doing was what normal was supposed to look like. Problem was, if that was true, I didn't look very normal. I looked like an aging dad who taught at a small liberal arts college.

That is, unless you saw me online. For on the Internet I had created an uber-persona.

I thought that if I was going to make a run at a second career as a photographer, I needed to move quickly. And so, as I mentioned early in the book, I unconsciously adopted the "fake it till you make it" mindset. It was so easy to do online. I could say anything I wanted!

Internet marketing was still in its infancy and I was eager to become an early adopter. I'd spend my evenings combing the Web, looking for places where I could tell people how I wanted to be perceived.

Despite these late-night efforts, my job pipeline wasn't getting filled. I had landed my first few jobs as referrals from David. Since then, the phone had been mighty quiet.

I hadn't heard from David in a while, so I decided to call him up and see if there were any crumbs he could throw my way.

Turned out, there were more than crumbs. In just his second year of shooting, David had an unbelievable 100% booking rate. That is, literally every potential client he spoke with booked him on the spot. But even with overflow work coming his way, he was not referring any people to me.

After a few minutes of small talk, I cut to the chase and asked him why he wasn't passing on to me the referrals I felt so entitled to.

His response changed everything for me. At the time it seemed severe and it stung badly. In retrospect, it was the gift that launched my career. It was the moment David Jay became my true friend.

David replied that he couldn't in good conscience encourage people to use my services. As we spoke, he Googled my name and read aloud: "Dane Sanders, Santa Barbara's Premier Wedding Photographer..."

"That's just not true," he said. "I can't support someone who doesn't tell the truth."

When he read the lies I had written online, I felt hurt, angry and oddly relieved to have been found out. I knew in my gut that I was just kidding myself. And so my friend's words rang true. I was a faker.

Now, to be fair, there were some compelling reasons—at least I thought there were—for choosing the strategy I'd taken on. Following some very bad advice that was circulating at the time, I came to believe that if I was going to make it, I needed to pretend to be like those I perceived to be successful. What I naively misunderstood, however, was that the keys to their success had little to do with my potential success. To try to emulate their approach was a sucker bet. There was no chance I could ever win.

My wife has told me many times throughout our marriage that I'm an all-in kind of guy. It's everything or nothing with me. So when I real-

ized the mistake I'd made, I felt an extreme urge to run full force in the opposite direction. And so I did.

I spent most of the next few weeks trolling the Internet to make things right. I was like a motivated twelve-stepper stuck on step number eight: making amends. I went on an "extreme honesty mission." The wannabe rock star had come crashing back to reality.

My "premier wedding pretender" brand had been cut down to just Dane Sanders: husband, father and lover of photography. Hire me as I am or not at all.

Then the unthinkable happened. Suddenly I started to book weddings! In being honest with who I was, I not only liberated myself but in the process discovered a very convenient truth: Authenticity sells. I also discovered a corollary to this truth: You can't fake authenticity. In the end, people figure it out.

The New Me was the Old Me

In short order, I established credibility simply by being honest. It turned out I wasn't the only "fake it till you make it" photographer in the wedding world. Just by telling the truth, I was suddenly standing out from the pack. On the heels of what I thought was going to be a career-ending declaration, I found myself with more opportunities than I knew what to do with.

In addition to increased bookings, another surprise came my way. David Jay and I deepened our friendship. In addition to camera talk, we began exploring bigger ideas about life and business beyond our industry. These were (and are) some of the most profound conversations I've had the privilege of partaking in. The more we talked, the less interested both of us were in talking shop. Yet I still needed help with my photo life.

So instead of asking David questions in person, I got in the habit of

writing DJ emails when I wanted "shop" advice. One day I wrote him and asked one such photo-related question. His response was a curious one to me. He told me to ask it on the forum.

"What's a forum?" I responded. After his quick explanation that a forum was like an online chat room, only better, I figured out how to log on and post. He responded to my post online and my query was solved. What seemed weird to me at the time was that he and I were the only people online. In total, the forum "community" consisted of four members.

When I asked him later why I couldn't just send my question via email, he said to trust him - in time people would start showing up. Sort of an "if you build it, they will come" thing. He even prophetically suggested that our back-and-forth conversations, sharing what little we knew at the time, might start a mini-movement.

Well, David's forum has evolved into what is now known as the Open Source Photo (OSP) community (http://opensourcephoto.com). As of this writing, there about 8000 members from all over the world.

As a professor, teaching and writing were comfortable to me. So, when the online medium of forums emerged, I found a clue to my unique opportunity to contribute. Although I wrote fewer posts than most, I crafted thoughtful responses to key questions and conversations. As I did, I found something new in me: a unique voice.

I didn't realize it at the time, but others were noticing me. Almost by mistake, I started to become a leader just by making my own positive contribution.

One day Pictage (http://pictage.com), the world's premier order fulfillment and photo lab company, invited me to play a community leader role on their new online forum. Modeled in many ways after the OSP community, the Pictage forum was for members only and was the company's first foray into building community around its brand.

At the time, I'm not sure any of us truly understood the power of the Internet. It was only the sense of community that drew many of us to participate. Of course, there were other online photo communities that were much more established than either OSP or Pictage, but many had developed the reputation of not being the kind of place to go if you were new to the industry. They were havens for Grumpies.

One very prominent forum that still exists today was notorious for being the ultimate in Grumpy Networks. Its community moderators seemed to view limiting the sharing of knowledge and discouraging open dialogue as their primary duties. So, being asked to play a leadership role on the far more positive and encouraging Pictage Forum was a true gift to me and, as it turned out, a gift to others.

Blogs, 'Pods and Vodcasts

I started keeping a blog that a handful of folks who knew me from the forums began to visit. I would post regular content about the stuff I was learning about the photography world and people seemed to really appreciate it. I began to feel that karma rush of getting back even more than I was giving. And, in contrast to my experience less than a year previous, I had nothing to hide or manipulate. I was just sharing what little I knew and, in doing so, was adding value to our community.

It was around that time that I began to get wind of a new technology that many futurists were predicting would have a dramatic impact. It was called a podcast. The only drawback was, the bulk of these online programs were strictly audio—not an ideal medium for photography content.

I started thinking about the evolution of radio to television and began madly researching what it would take to create a video podcast for photographers. I remember sharing this idea with friends. Almost all of them were kind, yet skeptical as to what use this new technology would serve.

With the help of a friend, I managed to create my first show in late 2005. I called the show The Simple Photo Minute (later changed to Dane's Photo Minute). I committed to producing a new show every week. Each episode featured a new angle on some bit of industry knowledge I'd gained. I would call photographers I wanted to get to know and ask them if I could come by their studios and homes to do "cribs" episodes. I would ask them to open up their photography bags and share what was inside. As a recovering gadget guy, whenever I found a new piece of hardware or software that inspired me, I'd vodcast about it. Companies began sending me free products in case I wanted to review them or do product placement in my shows. I was having a blast.

Even with all the fun I was having, I was constantly amazed to see the number of visitors to my vodcasts proliferate. But watching abstract numbers climb was nothing compared to what I was in for next.

My "Ah-ha" Moment

About three months into my Photo Minute endeavor, I attended my first Wedding and Portrait Photographers International (WPPI) convention in Las Vegas. At the time, I was also a member of the Digital Wedding Forum (DWF) whose conference convened at the same time at a different hotel in town.

When I arrived at my hotel and got on the elevator, the gentleman next to me gave me an odd glance. "Hey, you're the Simple Photo Minute guy," he exclaimed.

Flattered, I replied that indeed I was. What happened next absolutely floored me. This gentleman proceeded to pull out his high-tech phone and scroll through all of the episodes of my vodcast. He had all of them stored there! He was so enthusiastic, he could barely contain himself.

After dropping my bags in my room, I swung by the hotel bar to meet a friend. Almost immediately, another photographer identified me as

"the Photo Minute guy," bought me a beer and introduced me to everyone he knew. I was in a state of shock. In the blink of an eye, I had become a known quantity.

Throughout the rest of the week I was stopped regularly as I walked the tradeshow floor. People would chat with me as though we were old friends. This phenomenon, combined with meeting in person many of my new friends from the forums, created an instant sense of global community. I got it.

Over the following months, I continued to create content and in less than a year I had over 100,000 visitors to my blog each month.

Attack of the Grumpies

What amazed me most of all was how skeptical certain industry people were about what I was up to. Two very different types of photographer began to gel into focus for me. The first ones were the appreciative ones. These tended to be newer photographers who offered sincere gratitude for what I was creating. The second ones were the cynics. These Grumpies were often more seasoned photographers, convinced that I had some ulterior motive for giving my "Photo Minutes" away for free.

Now, to be fair, if I could have figured out a way to make money on my vodcasts I would have. But, even if I had, I still wouldn't have understood what I was doing wrong in the eyes of the Grumpies. They and their Grumpy Networks would spend incredible amounts of time and energy trying to figure me out and cynically predicting my next move. My sincere efforts were viewed with total suspicion.

Fortunately, this gift I was offering to wedding photographers around the world became another karma kickback. The truth is I couldn't have bought the kind of publicity I was receiving for any amount of money. The most unlikely of suspects—me—had become somewhat of a household name.

But There was a Problem

It turned out that this priceless gift actually came at a high cost.

Remember, I was not a single guy with unlimited discretionary time. I was married. I had a growing family. I also still had a full-time job as a professor. Wedding photography was my side gig. Video podcasting had now become my side gig to my side gig. Yet, of all the things I was doing, this particular vehicle was the one thing that leveraged my uniqueness more than any of the others. I couldn't give it up. Not only did I love creating the vodcasts, but they were also my most powerful vehicle for contributing to community and building professional relationships. But something had to give!

That's when it hit me: I had to make a personal commitment to do only the things that I alone could uniquely do. I was forced into a corner where I had to give up whatever was not uniquely made for me and my strengths.

Now, discovering what I needed to give up and what I needed to keep became a somewhat painful process. It involved a lot of trial and error. I began to wonder: What if the process I was going through could help others more painlessly find their unique fit in the world of photography? I became convinced that a lot of people could benefit if I could learn how to articulate these patterns. And that was how this book was born.

So you're holding in your hand the very result of the process I'm sharing with you.

Why I'm Telling You My Story

On the heels of your discovering your own pDNA results, I want to give you a sense of how my own results might have appeared at the beginning of my career and how they would appear now. Unfortunately for me, I didn't have the pDNA test when I was starting out—I had to

create it! Looking back, though, it seems pretty clear what my results probably would have been.

If I had taken the pDNA when I was starting out, my results would have read something like this:

pDNA CATEGORY	pDNA RESULT	pDNA SHIFT
Experience	LOW	
Self-Starter	HIGH	
Program-Starter	MEDIUM	
Confidence	LOW	
Risk Tolerance	MEDIUM	
Need for Control	MEDIUM	
Need for Collaboration	HIGH	
Artistic Identity	LOW	
Entrepreneurial Identity	MEDIUM	
Attractiveness	LOW	
Grumpy Factor	HIGH	
Creativity from People	HIGH	
Creativity from Self	LOW	
Self-Promotion	LOW	

Taking the pDNA today, my results now read more like this:

pDNA CATEGORY	pDNA RESULT	pDNA SHIFT
Experience	HIGH	from LOW to HIGH (dramatic)
Self-Starter	HIGH	stayed the same
Program-Starter	MEDIUM	stayed the same
Confidence	HIGH	from LOW to HIGH (dramatic)
Risk Tolerance	HIGH	from MEDIUM to HIGH

pDNA CATEGORY	pDNA RESULT	pDNA SHIFT
Need for Control	LOW	from MEDIUM to LOW
Need for Collaboration	MEDIUM	from HIGH to MEDIUM
Artistic Identity	MEDIUM	from LOW to MEDIUM
Entrepreneurial Identity	HIGH	from MEDIUM to HIGH
Attractiveness	MEDIUM	from LOW to MEDIUM (dramatic)
Grumpy Factor	LOW	from HIGH to LOW (dramatic)
Creativity from People	MEDIUM	from HIGH to MEDIUM
Creativity from Self	MEDIUM	from LOW to MEDIUM
Self-Promotion	HIGH	from LOW to HIGH

Note that my pDNA has changed quite a bit since the start, as yours no doubt will as well. This is why I recommend photographers take the test annually. To get a sense of how they've objectively progressed. Not a bad gift to give yourself for less than the price of a cab ride.

Wait a Second...

"But how can this be a DNA test if characteristics change over time?" you may be asking. "Isn't DNA hardwired? How can so many traits shift so much?" Great questions.

The reason things shifted for me (and why they probably will for you) is not because the results aren't accurate. It's because the more you evolve in the industry, the closer you actually get to who you were truly meant to be as a photographer. You are in the process of becoming more yourself.

You see, when we're new to the business, many of us develop adaptive behavior based on our circumstances. We adapt in order to survive. As our circumstances improve and survival becomes less of an immediate concern, we discover more and more leeway to be our true selves.

As an example, think about families. A child in a "dysfunctional" family must adapt and find the safest and most functional role she can play in order to survive within the family unit. In healthier families, children are encouraged to find their true selves while they are young and to mature along those lines. In the less-than-healthy families, children bide their time, playing their adaptive roles, until they become independent adults, at which point they often appear to do a dramatic about-face. If you survey these people, however, they will often say that they didn't really change; it's just that they were finally freed up to be their true selves.

In a sense, that's what happens for the maturing photographer. There is often a truer version of ourselves waiting in the wings. It takes time for newcomers to discover what they were meant to be. While this is happening, we are often forced into playing adaptive roles that don't always fit. In short, we are trying to survive, rather than thrive. It often isn't until we've been around the industry for quite a while that we settle into who we really are.

The pDNA test is meant to help you expedite that process.

Expect Change

Some categories of your pDNA will change naturally as time goes on. For example, if you stick around long enough, your Experience will definitely increase. Other categories are less flexible. There will rarely be dramatic shifts in some of these unless you have a dramatic epiphany. (This is why it's so challenging to lose the Grumpy virus once it catches.)

For me, besides Experience, the other two categories that shifted dramatically were Attractiveness and Confidence. It feels odd to assert that I became more attractive and confident as I matured in the industry. But that is what will likely happen to you too, as you mature into who you were made to be as a photographer. As you become more yourself, you will automatically become more attractive and confident in who you are and what you uniquely bring to the table.

Of course, when I use the word "attractive," I don't necessarily mean physically attractive (though that can happen too, as inner confidence grows). I am referring to your level of personal and professional magnetism. Some people "pull" others, some people repel others, others are neutral; it's that simple.

When I first began working as a pro, I remember feeling painfully invisible. I constantly second-guessed my choice to jump into this game. It has been rewarding to notice an almost direct correlation between my comfort in my own skin and my outward "attractiveness" as I've increasingly embraced who I am and what I uniquely contribute to our field.

Of course there are plenty of phenomenal photographers light years more attractive and confident than I. But to get lost in the comparison game again would absolutely miss my point. What has increased in potency is the photography category of "me." I am being maximized as I mature. This has come at the cost of a series of challenging choices. These are the kinds of choices I want to invite you to consider making sooner rather than later.

How might you align your brand to more accurately reflect your you-niqueness?

The next chapter will invite you to look more specifically at your pDNA readout and to start to dream a bit as to what might be your best fit in the industry tomorrow. Again, there has never been a more ideal time to become the professional photographer you've dreamed of being. With your pDNA in hand, your dreams are about to become more vivid than you knew possible. The incredible opportunities of our times are yours for the taking. The trick is fitting who you actually are—personality, preferences, circumstances and all—into the professional photographer landscape we now live within.

But, the good news is, it's absolutely doable.

CHAPTER FIVE

Dream a Dream with Me

"Photojojo Is Your Friend"

Photojojo (http://photojojo.com) is one of the best Do-It-Yourself (DIY) photography websites on the Internet. It is both lighthearted and cutting-edge at the same time. It encourages anyone with a camera to take pictures in a more fun way. On the surface, its clever copy, intriguing how-tos and recommendations of neat stuff seem to be what has made Photojojo the special place its readers love. But I'm not convinced any of these reasons is why Photojojo has become so popular and so compelling to so many.

There are lots of slick photography-related sites that promote DIY ideas and cool gadgets. Photojojo has figured out how to transcend that generic category precisely because it knows what it uniquely contributes to the community it serves and what it does not contribute.

If you talk to any of its loyal fans (and there are a lot of them), Photojojo just feels different. Unlike the numerous cold and cerebral photo review blogs and commercial sites, Photojojo has a unique charm to it that is tough to pin down and even tougher to replicate. No individual or personality is promoted there. It's almost as if the site is bent on deflecting the personal spotlight.

Who is Photojojo anyway, you might ask? It's almost as if the site itself is not the point it's trying to promote. Photojojo doesn't seem to exist to become popular in and of itself, despite the fact that it is. The feel of the site seems to communicate that its reason for being is just to help.

Owning Your Limits & Dreaming for the Stars

"Photojojo is your friend" was the original tagline used by the site. The idea that Photojojo is (or ever could be) "your friend" seems silly on the surface. How can an impersonal website befriend you? Yet, to the legions of faithful who start their days by logging onto Photojojo, it seems to resonate. There's just something about the Photojojo brand

that makes you feel excited about what is possible for you in the photo world. Sure, it shares clever tricks and inside scoops on gadgetry, techniques and fun ideas in the photo world, but what it really delivers, in a consistently trustworthy and friendly way, is one simple thing: hope.

And it delivers that hope to users in some pretty creative ways. Whether it's hope for discovering some brand new idea, hope for learning some new trick or even hope of finding a friend, the reason Photojojo feels so special is because it is in the optimism business.

But how did Photojojo get there? How did its designers create a brand that reflects cool and friendly hopefulness in such an appealingly hip way?

And perhaps the better question is, why is it stopping there?

If any entrepreneur were to stumble onto the site, you can be sure s/he would see the potential for exploiting the target demographic that faithfully pours in. Even to the non-business-minded, the more you're on this site, the more you get the sense that what it does for amateur DIY photographers it could easily do for all areas of photography. Why not make Photojojo the ultimate hub for all things photo-related? Why not sprinkle its "coolness" onto the professional gear review genre, for example, and call it Photoprojo?

I suspect the reason Photojojo's owners don't do this is because they're smart enough to understand where they are great and where they may not be great. The website's value lies not just in doing what it does well, but in its willingness to acknowledge what it probably would not do well. By owning its limits and maximizing what falls within those boundaries, Photojojo has become the phenomenon that it has.

Who's Behind the Curtain?

Amit Gupta is the brains behind Photojojo. Amit is the epitome of the Digi-Flat entrepreneur. He gets that the new world is flat, that the Internet is run by the people (not "The Man") and that a new day has

dawned in the world of service-based commerce. After a series of successful ventures, Amit is in the midst of creating a worldwide phenomenon for photography enthusiasts through the Photojojo brand.

His true brilliance, though, is in his intuitive ability to make his brand deeply reflect his own strength set. Photojojo starts with who he is and stops where his strengths end. Amit himself is a true amateur photographer, in the loving sense I describe below. When you meet him, his enthusiasm and affection for others is obvious, but not presumptuous. He never forces himself on you, yet that's part of his charm and why people are drawn to him. His primary concern is not himself, but whatever is on the minds of his friends and associates. His job is to help people, even if he doesn't know their personal lives very well. He finds their passions interesting anyway.

Photojojo is like Amit's virtual persona. It's his own personal Second Life.

I bring up Photojojo at the start of this chapter for two reasons. First, because it is a superb example of a Digi-Flat enterprise that succeeds by keeping its focus only on what it does uniquely well. (We'll come back to that idea in a few minutes.) Second, because of the specific topic of that focus: learning to look at your craft from new angles and to have fun with it. Even for the established pro, Photojojo is an invitation to return to a photographer's first love…creativity.

I'd like to talk about that love before we go anywhere else.

The Lover's Affections

Amateur. What does the word mean?

I want you to know that I have an extremely high opinion of the term. Yet when many use the word, they intend it as derogatory or demeaning. As in, "that newbie is such an amateur." When I use the word amateur, I mean it in the classic sense of the word, in the same way that Olympic athletes are amateurs.

I realize that many people don't consider Olympic athletes amateurs anymore. Not only is the degree of skill they display mind-blowing, but so, too, can be their salaries. Many highly paid "professionals" are now allowed to compete on the Olympic stage.

But when I use the word, I am not speaking of skill or salary level. I'm speaking of motivation. Why would world-class professional tennis players compete in the Davis Cup with no money on the line? Why would NBA basketball stars give up their summer vacations to play in the World Championships or Olympic games? Answer: they don't do it for the money. Olympic athletes compete because they love the game.

At heart, I am an amateur photographer. And so is almost every great professional photographer I know. To be an amateur is not to be naive or poorly skilled. It is a matter of the heart. Amateurism is a love of the game. It is the motivation to shoot regardless of whether we get paid. It's the magic that caught our hearts and made us fall in love with photography in the first place.

The root of the word amateur is the same as that of the word "amore," or love. Amateur means someone who does something for the pure love of it. So, when used correctly, the term amateur ought to be equated with a true lover.

To be a true amateur, regardless of what kind of photos you produce, means to be driven to take pictures regardless of the compensation. By distinction, being a professional photographer means that you leverage your skill at shooting to produce wealth and freedom. The two categories are different but not mutually exclusive.

For the newcomer to the field, I encourage you to leverage your amateur drive to become a professional. That is, take what you love and develop and focus it in such a way as to generate income. And as you build your skills, make more money, and experience more freedom, I urge you to cling to your amateur status for your whole career. Not only

will you probably become wealthier, you'll avoid becoming a Grumpy, which may be the best news of all.

For the seasoned professional, as you consider how to build your ideal business, I urge you to hearken back to your first love and reclaim what is rightfully yours: your passion for photography.

Change Your Job, Keep Your Heart

So let's be clear about this: I don't believe for a second that you need to give up your love for photography—your amateur status—to become a professional. In fact, I believe quite the opposite. But you do need to bring a different attitude-set to the table if you want to go pro. The focus is no longer just on what you enjoy, unless of course you are independently wealthy. Once you cross the threshold into the "paid for" world, you have a new master to serve: the client. The trick is to serve the new master in a way that does not throw your love of photography under the bus.

How you go about doing that will define your success, and happiness, as a professional.

When you are doing photography strictly for yourself, you get to pick and choose what tasks you want to do. This is why Photojojo is so adored around the world. It inspires people to stoke their passion for photography on their own terms. And this doesn't have to stop once you go pro. However, if I were to suggest that being a professional is just like being an enthusiast/amateur, with the exception that now you get paid, I would be misleading you and indulging in fantasy (a lovely fantasy, no doubt, but a fantasy still).

The truth is, when you're on the clock, there are other stakeholders involved—namely your clients—who have a say as to what you ought to be passionate about. As a professional, it is your job to serve your clients. (This is a side of the business rarely discussed in Photography

school.) The trick to being happy is to decide who you will choose as your clients. The gorgeous part of building your business in the Digi-Flat era is that you are the ultimate Master because you get to decide who your clients will be. And it all flows from keeping your true amateur heart alive.

Global Reach Means a More Customized Clientele

In the era of photography we've left behind, a photographer's business was basically local. Most pros had to be "generalists," because they had to serve the needs of the local community in which their business was located. There was little need for specialization or differentiation. Quite the opposite, in fact. You were better off following standard business formulas and offering customers the general range of services that were typically expected from a photo studio. Being too stylized or restrictive in your offerings would have made poor business sense, as a general rule.

I hope I've convinced you by now that the emerging Digi-Flat marketplace no longer offers you the "luxury" of being generic. It does, however, afford a far greater opportunity than ever before to differentiate yourself and build a "you-nique" enterprise that leverages your signature strengths. The simple fact is, the more global the marketplace, the more you can "reach out" and attract exactly the customized clientele you want to build.

The Internet, as we've seen, is a global marketing tool of staggering import. Over the past few years, it has been busily transforming itself from an experimental, "geek"-driven medium to a mainstream powerhouse. With cell phones and PDAs now becoming Internet portals, that shift has gone into high gear. As television becomes more interactive and web-connected over the next few years, that revolution will be 100% complete. The global marketplace will soon be the marketplace. For many of us, it already is.

On one level, of course, a wedding photography business will always remain a somewhat local enterprise. Most of us will not be flying to Moscow or Paris to shoot weddings (though high-end Signature Brand Photographers will certainly be doing so). But in the Digi-Flat era, we can, and must, expand our reach beyond the neighborhood, the town, the city and find those unique clients who previously might have eluded our grasp. We can now market a very particular brand of service to a very particular type of client. Rather than fishing with a wide net, as in the old days, we can now pursue a particular size and species of "fish" with a specially-designed "lure." We now have the tools to seek out the people in our larger community who share our tastes and who value our trademark skills.

Think about social clubs for a moment. In the old "localized" world, a neighborhood might feature, for example, an Irish American Club. It would not, however, have featured a club for Irish-American, Non-Smoking, Non-Drinking, Single Parents with Teenage Kids Who Are Interested in Rejoining the Dating Scene. That would have been too specific a charter for a local club to sustain. However, the Internet allows just such specificity. Its reach expands to a much wider area, using much more selective filters. It allows us to avail ourselves toward a far more customized clientele.

And the great news is, if we find the right clients, we don't need a massive number of them in order to prosper.

One Thousand True Fans

Kevin Kelly, on his web page called The Technium (http://www.kk.org/thetechnium), proposes that all a creative artist needs, in order to make a living from his work, is one thousand true fans. Here's how he puts it:

> » A creator, such as an artist, musician, photographer, craftsperson, performer, animator, designer, videomaker, or author—in other

words, anyone producing works of art—needs to acquire only 1,000 True Fans to make a living.

» A True Fan is defined as someone who will purchase anything and everything you produce. They will drive 200 miles to see you sing. They will buy the super deluxe re-issued hi-res box set of your stuff even though they have the low-res version. They have a Google Alert set for your name. They bookmark the eBay page where your out-of-print editions show up. They come to your openings. They have you sign their copies. They buy the t-shirt, and the mug, and the hat. They can't wait till you issue your next work. They are true fans.

» To raise your sales out of the flatline…you need to connect with your True Fans directly. Another way to state this is, you need to convert a thousand Lesser Fans into a thousand True Fans.

» Assume conservatively that your True Fans will each spend one day's wages per year in support of what you do. That "one-day-wage" is an average, because of course your truest fans will spend a lot more than that. Let's peg that per diem each True Fan spends at $100 per year. If you have 1,000 fans that sums up to $100,000 per year, which minus some modest expenses, is a living for most folks.

» One thousand is a feasible number. You could count to 1,000. If you added one fan a day, it would take only three years. True Fan-ship is doable. Pleasing a True Fan is pleasurable, and invigorating. It rewards the artist to remain true, to focus on the unique aspects of their work, the qualities that True Fans appreciate.

» The key challenge is that you have to maintain direct contact with your 1,000 True Fans. They are giving you their support directly. Maybe they come to your house concerts, or they are buying your DVDs from your website, or they order your prints from Pictopia. As much as possible you retain the full amount of their support. You also benefit from the direct feedback and love.

» The technologies of connection and small-time manufacturing make this circle possible. Blogs and RSS feeds trickle out news, and upcoming appearances or new works. Web sites host galleries of your past work, archives of biographical information, and catalogs of paraphernalia. Diskmakers, Blurb, rapid prototyping shops, Myspace, Facebook, and the entire digital domain all conspire to make duplication and dissemination in small quantities fast, cheap and easy. You don't need a million fans to justify producing something new. A mere one thousand is sufficient.

Not everything Kelly says applies directly to our work as photographers—and the number of True Fans required may differ—but I do believe this article contains a strong seed of truth you need to understand as you build a custom business in these globalized, Digi-Flat times.

Serving Two Masters

Your job as a professional photographer is to serve your clients. But, in a marvelously reciprocal way, who your clients will be is determined by you.

In either kind of business, Freelance or Signature Brand, it's helpful to remember that you're always really serving two masters, in fact. Being clear on this will help immensely in your day-to-day decision-making process. Let me explain what I mean.

Let's say you're in the Freelance Photographer business. You are, in a sense, a hired gun. Your job is to show up and meet or exceed the standards laid out by your employer. Your two masters are (1) the client and (2) the company that employs you. Naturally, serving the client is extremely important. S/he must be happy with your services and your photography. But the second master, the company, is vastly more important, because if you serve that master well, and serve it in a way that's true to you, then more of the kind of clients you want to serve will be coming your way.

If you're building a Signature Brand Photographer business, you also serve two masters.

The first master, again, is the client who hires you. The more primary master, though, is the brand you are building. You can afford to give up some customers if it means you are communicating your brand in a way that's more aligned with your uniqueness. Because, in the end, doing so will bring you more of the kind of client you want to serve.

Since you decide what your brand's essence is, you ultimately decide who your clients will be. The people who will be attracted to you are the people you will want to serve. Which, in the end, means you are always the true master. You are both servant and master of the client you choose to serve. Do you see how it works? You control the whole game, as long as you're clear and committed to who you are.

Insert *Your Dreams* Here

If you want to attract your ideal clientele, it all comes down to clearly identifying what you do passionately well and then offering that service to the world in your unique way. So how do you go about doing that?

Well, you've taken your pDNA and this should already have gotten your juices flowing. Before we get into further interpreting your pDNA results, though, I want you to take a deep breath and revisit your original dreams with photography. I want you to reawaken the amateur within.

What was it about photography that caught your heart? When did you fall in love with the medium? Why? What pulled you into this field like a rip tide? What were the magnetic aspects of the craft that made your heart skip? What made you entertain the possibility that you might put everything on the line to get in this game?

Remembering what propelled you into photography in the first place will help you discover some critical clues as to the direction you ought to take from here. Looking at those clues against your pDNA results should bring a whole new level of clarity to the process.

So before we go any further, I'd like you to do the following exercise. You can do the whole thing in one sitting if you wish. But in order to get the most benefit, I'd recommend doing it over three sittings. At first I'm going to ask you, knowing what you now know, to describe your imagined life as a Freelance Photographer in vivid detail. Then I'm going to ask you to do the same for a possible life as a Signature Brand Photographer. Then we're going to reintroduce your original dreams into the mix. Fair enough? Let's do it!

Round One: Imagining Life as a Freelance Photographer

Keeping your pDNA results in mind, describe in detail what your life might be like as a Freelance Photographer—that is, a shooter who is hired, for a fee, by an employer to shoot specific events. Paint the most attractive picture you can of yourself in this career path. Try to look only at the positive aspects, suspending all negativity and criticism (except when answering the final question).

Really imagine the answers to these questions as clearly and specifically as you can.

Describe a typical day in your life as a Freelance Photographer:

Morning:
Afternoon:
Evening:
What is your schedule like on a busy shooting day? What kinds of tasks do you do? What are your priorities?
What is your schedule like on a non-shooting day? What kinds of things do you do? What are your priorities?

How does your business look and feel when you have a lot of jobs lined up? How does it look and feel when business is very slow?
What kinds of non-shooting tasks must you routinely do as a Freelance Photographer?
What kind of workspace do you have? A home office? A home studio? A separate office or studio?
What life and career benefits do you derive from this type of work? How does it affect your relationships, lifestyle and housing choices?

Describe the freedom you experience as a Freelance Photographer:

What enjoyable tasks does this kind of work allow you to do?
What kinds of things are you proud of in your life and business as a Freelance Photographer?
How do you feel when you tell others about your career?

Finally, as a Freelance Photographer, describe what things you find:

Disappointing:
Difficult:
Unfulfilling:
Lacking:

Boring:	
Stressful:	
Undesirable:	

Round Two:
Imagining Life as a Signature Brand Photographer

Keeping your pDNA results in mind, describe what your life would be like as a Signature Brand Photographer. You run your own business and you market yourself as a brand. Again, paint the most attractive picture you can. Try to look only at the positive aspects, suspending criticism until the end. Let your imagination really get into it.

Describe a typical day in your life as a Signature Brand Photographer:

Morning:
Afternoon:
Evening:
What is your schedule like on a busy shooting day? What kinds of tasks do you do? What are your priorities?
What is your schedule like on a non-shooting day? What kinds of things do you do? What are your priorities?
How does your business look and feel when you have a lot of jobs lined up? How does it look and feel when business is very slow?

What kinds of non-shooting tasks must you routinely do as a Signature Brand Photographer?
What kind of workspace do you have? A home office? A home studio? Both? A separate office or studio? Why?
What life and career benefits do you derive from this type of work?

Describe the freedom you experience as a Signature Brand Photographer:

What enjoyable tasks, beyond shooting pictures, does this kind of work allow you to do?
What kinds of things are you proud of in your life and business as a Signature Brand Photographer?
How do you feel when you tell others about your career?
What are the main ways your life differs from that of a Freelance Photographer? How are the rules, expectations and routines different?

Finally, as a Signature Brand Photographer, describe the things you find:

Disappointing:
Difficult:
Unfulfilling:
Lacking:

Boring:
Stressful:
Undesirable:

Round Three: Remembering the Dream

Now please make a strong effort to recall what your dreams were before you considered the Fast Track Photographer System. Remember in vivid detail the things you imagined yourself doing as a pro. Include the fantasies you had when you first thought about becoming a photographer. Don't be embarrassed, be honest.

Describe a typical day in your dream life as a Photographer:

Morning:
Afternoon:
Evening:
What is your schedule like on a busy shooting day? What kinds of tasks do you do? What are your priorities?
What is your schedule like on a non-shooting day? What kinds of things do you do? What are your priorities?
How does your business look and feel when you have a lot of jobs lined up? How does it look and feel when business is very slow? What kinds of things do you do?

What kinds of non-shooting tasks do you routinely do?
What kind of workspace do you have? A home office? A home studio? Both? A separate office or studio? Why?
What life and career benefits do you derive from being a Photographer? How does it affect your relationships, lifestyle, social life and housing choices?

Describe the freedom you experience being a professional Photographer:

What enjoyable tasks, beyond shooting pictures, does this kind of work allow you to do?
What kinds of things are you proud of in your life and business as a photographer?
How do you feel when you tell others about your career?

After doing the Round Three exercise, compare your early ideas to your more-informed Freelance Photographer vision and Signature Brand Photographer vision.

The vision you began with probably looks a little different to you now. Like adding spot lights and fill flash simultaneously, you should be able to see more.

For some of you, this will feel incredibly validating. Your intuitions were on target and you're more convinced than ever that the dream you had for your career in photography is right. Your laser-like gaze is focusing ever more clearly on the prize.

For others, you may feel discouraged or may be second-guessing your

dreams. Your pDNA results, along with your answers to the above questions, seem to be suggesting a kind of pro photo life that you weren't anticipating. Letting your dreams evolve or perhaps even die is painful. You may be considering calling it quits before you even get started. Don't worry. What you're doing is maturing. As with all passages in life, letting go of old notions can be sad, but what you're growing into has far more potential to ultimately satisfy your passions.

But here's an important point. *I don't want your dream to be completely lost to compromise.* I'd like you to take a few minutes to capture the important nuggets from your original vision before they erode away. Now look for ways to connect your old dreams with your updated vision. Treat your new and more vivid dreams as an *evolution* of what you started with, not as a replacement.

Now that you've done that, which of the two career paths—Freelance or Signature Brand—seems to best serve your newly-minted vision of what you want to be as a professional photographer? Taking into account what originally drove you into photography, your pDNA, and what you now understand about a career as a photographer, which path (or combination of paths) now seems ideal to you?

You don't have to decide just yet, but know that whichever way you do decide, you'll have forged a strong foundation to act decisively. Great job!

Your Dreams Will Define Your End-Game

Often times, people who do this exercise realize that what they thought their dreams were about were actually about something totally different. Sometimes what motivated them to become a shooter ends up being more closely connected to some other aspect of the wedding photography world. Post-production work, for example, or event-planning or marketing or graphic art.

The value in getting clear on your dream is that your dream is the

end-goal you'll pursue, even if on an unconscious level. By making the dream, and hence the end-goal, conscious, you give it potency and purpose. Never again will you be wondering why you got into this thing in the first place. This clarity is a gift few in any industry enjoy. When discouraging days come, and of course they will, clarity about your dream will be like pure gold to you. Keep it in a safe place and don't forget it.

With the end-game clear, how you go about getting there becomes the only real concern. You will advance in confidence that you're heading in the right direction. You'll also gain clearer insight about making day-to-day decisions.

If your dreams are your ultimate prize, maximizing your pDNA strengths along the way is what will give you the most joy in your work. We'll be talking about that more in the next chapter.

Going Behind the Curtain Yourself

The hard part is over. You've gone behind the curtain and de-mystified the profession. Your perspective has changed and, as with any rite of passage, this can be disorienting. The world of photography should look a little different to you now than it did before we started.

I want you to know that even with the lights turned on and the curtains thrown open, your dreams have never been more potent than they are right now. Why? Because now you are actually discovering a course of action to live them out. The power you now possess is that you don't have to pursue your dreams in the same way your photo heroes did. You can now methodically go after them on your own terms, knowing both the costs and the ultimate rewards.

As we move on to the next section of the book, you'll be asked to make a decision about the kind of business you are building. If you've come this far, you can feel confident that you're ready to make this call. You know what you bring to the table, you see the full spectrum of possi-

bility within our industry and you have a good sense of your own true dreams. Now you get to connect the dots and make things happen.

CHAPTER SIX

Time to Make a Decision

Interpreting your pDNA

The pot at the end of the pDNA rainbow is to get clear on what you're designed to do as a pro. Once you're clear on that, you're golden. But if you're constantly trying to be something you're not, even if you believe that's what you're "supposed" to do, you're setting yourself up for heartache. It's that simple. Remember: the Digi-Flat world is ruthlessly competitive, except for those who've discovered what they're uniquely designed to be and do.

Of course, there are trade-offs built into your pDNA. Understanding those trade-offs is one of the keys to understanding your strengths. That will become clearer in a minute.

I'd like to point out, right up front, that the pDNA isn't the only helpful tool to help you understand yourself. Nor should you rely on it exclusively. I'm a huge fan of both the Strengthsfinder and the Myers-Briggs Type Indicator (MBTI), for example. Both are incredibly well researched and have been validated tens of thousands of times over. Dr. Martin Seligman's VIA Signature Strengths questionnaire is also an excellent all-around instrument for self-discovery. I would recommend you leverage all the tools you can to develop a strong working knowledge of yourself. Because who you are should always be a prime factor in what you do for a living and how you do it.

But if you're eager, as I suspect you are, to hone in on the qualities that matter most relative to *going pro,* please get out your pDNA now.

With your pDNA results in front of you, I'd like to remind you of two things:

1) The pDNA tool is not a pass/fail test. There is no moral judgment associated with your answers. Your results are neither good nor bad. They simply *are.* Resist the temptation to aspire to something you think you *should* be, but are not. This is a waste of your time. Instead, commit now to maximize your potential by embracing who you are.

2) Your results become more powerful the more you understand them *as a whole* rather than as isolated parts. It is in the *combination* of your characteristics that your true distinctiveness will begin to emerge. For example, let's say you and a friend have in common a HIGH Confidence Quotient. That tells you one very basic shared tendency, but the real potency emerges when you combine that quotient with different results in other categories. Let's say, for example, your friend scores a LOW Need for Control Quotient while you score a HIGH Need for Control Quotient. Factor that difference with your common confidence score and you will begin to see dramatically different photographer personality profiles.

For example:

HIGH confidence combined with HIGH need for control suggests that you feel highly competent in your craft *and* like to do many or most things yourself. You might be happiest in a one-person Signature Brand Photographer business, where you can personally handle/oversee many of the tasks of photo production yourself. If these two pDNA results were further combined with, say, a HIGH Artistic ID Quotient, you might discover that you'd be happiest pursuing a career, at least in part, as an artist-photographer whose works are displayed in galleries and shops, perhaps even books and museums. Your high need for control would likely be satisfied by carefully grooming all aspects of your photographs, from taking the shot to the finer details of post-production, framing and display. Your route to wealth might not be through scalability but through creating high monetary value for your photography. This might be a more challenging route, but that's one of the trade-offs inherent in following your own design.

HIGH confidence with LOW need for control suggests that you, too, feel highly competent in your craft, but are quite comfortable "sharing the wealth" when it comes to work. You would be very happy in a team environment, either as part of a group business or as someone who

focuses only on one aspect of the work, while outsourcing the rest to trusted associates. If these two results of yours were further combined, say, with a HIGH Entrepreneurial ID quotient, you'd probably be ripe for creating a highly scalable, highly replicable business where you hire many other photographers to work for you, bringing in lots of business while you focus on the few jobs or *types* of jobs you like best.

Expand those subtle distinctions across all of your pDNA traits and you begin to see how unique you really are, and how unique your business needs to be. In fact, the likelihood that you would share all pDNA factors with someone you know are almost nil. So now let's go after a deeper understanding of your particularities.

Getting Started

To help you visualize what this process of interpretation can look like, I've created a fictional photographer named Jake. Looking at Jake's results will help us understand both the correlation between the pDNA characteristics and the potency that can be generated by that correlation.

"Jake's" pDNA Results

pDNA CATEGORY	pDNA RESULT	pDNA SHIFT
Experience	LOW	
Self-Starter	LOW	
Program-Starter	HIGH	
Confidence	MEDIUM	
Risk Tolerance	LOW	
Need for Control	MEDIUM	
Need for Collaboration	HIGH	
Artistic Identity	MEDIUM	
Entrepreneurial Identity	HIGH	

pDNA CATEGORY	pDNA RESULT	pDNA SHIFT
Attractiveness	HIGH	
Grumpy Factor	MEDIUM	
Creativity from People	HIGH	
Creativity from Self	LOW	
Self-Promotion	LOW	

We can make a lot of inferences from Jake's results. Here are a few:

» He's relatively new to the photography world.

» He tends to need a little help to turn his ideas into action.

» He has potential to grow in his confidence.

» He doesn't like to take on too much risk, which is one of the reasons he likes control.

» With the right collaboration, I suspect his willingness to risk would increase, mainly because it would *feel* less and less like risk to him.

» He views professional photography as a business first and an art second.

» People want to be around him.

» He's humble enough to notice that he can be envious of others and if that doesn't stay in check, it could become a Grumpy liability.

» When he's around people, he gets more and more creative.

» When he's alone his motivation for creativity drops.

» He's nervous about promoting himself because he second-guesses his talent.

The point of looking at Jake's profile is to give you some idea about the types of considerations that arise when you calculate the chemistry amongst your various pDNA traits.

In Jake's case, one intriguing combination is his LOW Risk Tolerance and his HIGH Need for Collaboration. This could mean that with the right collaborators in his life, Jake could lower his experience of risk. Will that increase his tolerance of risk? Probably not. But the knowledge that he is risk-aversive empowers him to lower his exposure to risk by, for example, surrounding himself with a team of trusted partners. In this way he can perhaps distribute the risk and reduce potential individual loss for himself. Because he likes collaboration, he might also want to share management decisions and lower his risk even more.

Rather than trying to lower or ignore his fear of risk, or pretend he's a lone wolf when he isn't, Jake should acknowledge his natural traits and accommodate them in his business planning.

Now let's note that Jake has a LOW Self-Starter Quotient as well as a HIGH Program-Starter Quotient and a HIGH Attractiveness Quotient. This might make him an ideal candidate for photography school. Not only would it answer his need for support and structure, but his high attractiveness quotient might make him stand out among his peers. He has the potential to be a "star" student. Combine his strong need for collaboration with the fertile environment of photography school and his attractiveness might allow him to begin building a team of collaborative partners that he could carry forward into his professional life.

Life Must Be Factored In

But here's a very important point: our pDNA results don't exist in a vacuum. They must be considered within the context of our very real and present life circumstances. What might seem like an ideal course of action in theory must be tempered against what is practical and possible.

Let's look at Jake's life for a minute. He is a single guy who, like me, never really thought of himself as especially artistic. An important

consideration is that he's already been to college and has substantial student loans. The idea of going back to school to learn photography does not seem practical at this point in his life. He's not ready to do the whole school thing again. But he is nimble enough at this point in his life to try something new—if he were convinced it was the right thing to do. Remember, Jake's not big on taking risks.

Some other factors for Jake to consider:

He's got a day job he does not find meaningful, in an industry he cares nothing about. So he doesn't have a lot to lose by switching careers, and might in fact, have much to gain. This lowers his feeling of risk. To his advantage, his MEDIUM Artistic ID Quotient reveals that he's not caught up in taking his art too seriously. The trade-off is that, because he has failed to take his art very seriously, he has a steep learning curve in front of him. He has not experienced that intense drive to perfect and develop his craft.

Rather, Jake spends a lot of time wandering online for help with his potential photo career without the critical ability to distinguish valid input from junk input. In noting his MEDIUM Grumpiness Quotient, Jake was forced to admit that he often gets simultaneously jealous and inspired when he reads about photographers who seem to "make it" out of nowhere. His dominant belief is that if someone would just tell him what to do, he'd do it and be super successful too.

In the past, when asked by friends and family what he wanted to be as a photographer, Jake would always reply with a vague statement like, "I want to be successful." When pressed further, he would point to brand-ed photographers on blogs and photography forums. "I want to be like them." Strikingly, the individuals he would mention had dramatically different brands and business models.

Part of Jake's problem was that he didn't have eyes to see those differences.

Doing the pDNA test was an eye-opener for Jake. Armed with the discoveries he was making about himself, he began to find inspiration

from particular characteristics of these branded professionals, rather than their images in general. He especially resonated with those traits that aligned with his own, such as his LOW Risk Tolerance. Not all successful photographers, he found out, were mavericks or overnight successes. Some had built their brands slowly and carefully. Jake liked that. That meant caution was not just for timid losers. He was beginning to feel empowered.

Recognizing his HIGH Program Starter Quotient, he realized that, even though returning to school full-time was not a viable option, he could take a couple of affordable evening courses through the state college's extension program. That might be enough to jump-start him into action. Going online he quickly found two courses that were practically tailor-made for him: a weekend seminar on Professional Photography and a twelve-week course on Starting Your New Business. He signed up for both immediately.

Now he was getting excited. What used to feel overwhelming and vague was crystallizing for Jake. He had a clearer sense of direction.

Jake took stock of his HIGH Entrepreneurial ID Quotient. He realized that he loved the idea of building a business even more than the idea of "being a photographer." He was really attracted to the concept of branding and so he wrote out a Jake as Photographer "handbook," detailing the dos and don'ts of the Jake brand.

Based on several factors from his pDNA, including his LOW Risk Tolerance and his HIGH need for collaboration, he wrote a two-page business plan. It involved creating a core team of photographers with complementary talents who would be the owners/co-managers of the business and make decisions as a group. After carefully establishing themselves, they would train a team of associate photographers. The eventual goal would be to create a replicable, branded system and over the next five years to methodically start studios in several cities, all managed by the group partnership.

By taking the visionary step of detailing his brand and his ideal business structure, Jake began to come to grips with reality. He realized that, until now, he'd been unwilling to grow up. His vision for his future self included a refined, professional persona. But when he looked around his life, that's not what he saw. He saw a dirty bachelor apartment/future photo studio with dried up pizza on the counter and a week's worth of unwashed dishes in the sink. In his closet he saw a wardrobe of college sweatshirts.

The light was beginning to dawn.

The branding of himself as a photographer had to be comprehensive. He realized that every moment of his life was a branding moment. What he wore to the grocery store, how he spoke, the signature he used on his emails, which avatar he chose on Facebook, the posters on his wall, the comments he made on the Internet, his phone machine messages—all of it mattered.

This epiphany seemed to come out of thin air. But, of course it hadn't. It had happened because he had done the hard work of discovering and interpreting his pDNA, which allowed him to build his vision with concrete clarity.

Looking at Your Results

It is impossible to chart a course on a map unless you are clear on where you're starting from and where you want to go. Right? Until you get that clarity, you're bound to wander aimlessly or take countless wrong turns. Jake's vagueness about his career and his inability to get started on a fruitful path had everything to do with his lack of clarity about where he was now and where he wanted to go. Once he had that clarity, everything began to fall into place and his career went on the Fast Track. He suddenly knew where he was on the map and where he was going.

So, your first step in deciding which kind of business you will be build-

ing is to get clear on the combination of pDNA characteristics you bring to the table. This is not a light and casual task, I must inform you. In fact, I'm going to ask you to set a meaningful chunk of time aside to do it. The more time and effort you put into it, the better.

Synthesizing the implications of your pDNA results is not reducible to a formula. It is as much an art as a science. The "science" aspect is the hard data: your individual pDNA results. The "art" aspect is the way you combine the results and discover how they relate to one another and how they suggest specific choices.

How you interpret the dynamics between your characteristics is somewhat intuitive and personal. Some combinations of traits will suggest obvious truths and choices, others require more "art" to tease out their meanings.

I'm now going to suggest an exercise that should help you in your interpretation. Write each of your results—the characteristic along with your HIGH, LOW or MEDIUM score—on individual index cards. This will allow you to shuffle the cards and to easily explore your pDNA results in various combinations.

First take a look at each result, one at a time, and ask yourself if it truly resonates. If so, take it one step further and relate it to the card above or below it. By shuffling and recombining the cards, you can look at each result against each of the other results. Cards make this easy to do.

What ideas begin to emerge as you put various two-card combos together? Take notes!

After you've looked at all the two-card combos, try combinations of three or four cards at a time. Shake up your creativity by laying them out in different visual arrangements. Try rows, columns, triangular patterns. Spread them out. Overlap them. Does anything new come to mind when you arrange them vertically vs. horizontally?

Start looking for business characteristics that satisfy three, four, five, six

traits at a time. Like a juggler who keeps adding balls, one at a time, keep increasing the number of variables you consider.

Cards, of course, aren't strictly necessary for this work but I find them immensely helpful in trying out various trait combinations. Alternatively you can use brainstorming or diagramming software. Or any method that works for you.

The important thing is to creatively consider as many combinations of your pDNA characteristics as you can and see what they suggest. Imagine customized business models that satisfy more and more of your pDNA characteristics.

The more you "play" with your pDNA traits in an open-ended, creative way, the more you'll start to see a picture emerge. A picture of the unique professional photographer you were designed to be. It will feel as if you're looking in a mirror in a dark room as lights come up one by one. Your true beauty, strength and value will emerge.

It's Time to Do It

Okay, it's time to put the book down and go to work on interpreting your results. This part is all on you. For me to cover all of the possibilities that your pDNA results might suggest in combination with one another, and to factor these against your current life situation, would be mathematically impossible. Only you can interpret your results. As you do, here are a few final tips:

» If you get stuck or can't see clearly, bring in a trusted friend or mate to help you—the extra eyes can help.

» Pretend you're helping someone else interpret the same pDNA results as yours. What advice would you give him/her? Can you apply that advice to yourself?

» If you see a result that suddenly doesn't seem to fit for you, suspend

judgment for now. It *could* be that when you took the test, your answers were a little off. More likely, though, you don't *like* the result the pDNA test gave and you'd prefer to avoid that reality right now. Denial can be useful in the short term. Give yourself that grace for now and forge ahead.

» Don't use your present life circumstances as an excuse for not trying something that feels right. Yes, "reality" must be factored in, but try not to limit yourself too much.

» After you've been working at it for a while, stop. Go for a walk, meditate, lie on a hammock, take a nap or do some other quiet activity that will allow your subconscious mind to digest the work you've been doing. Then come back to it.

» Try doing a session at night and then another session in the morning.

» Jump on the Fast Track Forum (http://forums.fasttrackphotographer.com) and meet up with other fast trackers with common characteristics. How are they maximizing their strengths? What things are they doing that might inspire you, or you, them?

» Remember that a single score in isolation doesn't capture your makeup. Again, it's the *combination* of your quotients—the dynamic relationships among them, creatively interpreted by you—that yields the most accurate picture of yourself.

» Over the next several weeks, watch for ideas that seem to spring to mind spontaneously. You've gotten your subconscious mind working; it may take some time for it to do its best work. Also watch for odd bits of meaningful information—a magazine article, a TV spot, a poster—that come to you unexpectedly. What may seem like coincidence may in fact be providence helping you connect the dots of your future.

Good. Now go to work!

Intermission

Okay, I hope you are now reopening this book after a long pause. I hope you have devoted a good deal of thought and energy to analyzing your pDNA results in combination with one another.

What kind of picture has emerged for you? What have you learned about yourself? What kinds of business choices are likely to work or not work for you?

The process of committing to the business model you are ideally suited for might feel intimidating. Let me try to answer a few of the obvious questions you might be asking at this stage of the game.

Why do I have to choose a career path so soon?

You don't. But the name of this book is *Fast Track Photographer*. My aim here is to help you avoid much of the needless floundering and false-starting that can eat up years of a professional life. I want to empower you to "cut to the chase." You are certainly free to take a more experimental, free-style route if you feel that suits you. Understand that the trade-off is a certain amount of inefficiency. But that's okay. I believe that even if you do proceed experimentally, you will ultimately discover that you are happiest and most successful when you play to your authentic strengths, desires and tendencies. My aim here is to help you identify those qualities sooner rather than later. Will there be mistakes and dead-ends even if you follow the *Fast Track* System? Of course. But I believe there will be far fewer of them.

Why should I trust the results of some goofy test?

You shouldn't. You should trust yourself. The pDNA is only a tool for helping you take a more honest look at yourself. All tools are inherently limited. There may be categories that are important to you that the tool does not address. For example, you may feel strongly that your work should have a spiritual component or should contribute to social

change. By all means, include these considerations when you interpret your results. The pDNA results are only a vehicle to help you arrive at greater self-knowledge as it relates to a career as a professional photographer. Don't mistake the vehicle for the destination. The knowledge is what we're after.

What if I make the wrong choice?

With the right attitude, there is no such thing as a wrong choice. As Edison famously said about "failing" so many times in his quest for the right light bulb filament, "I never failed once. It just happened to be a 2000-step process." A "wrong" choice is simply a pointer to a better choice. Making *some* wrong choices is the only way we know when we're making right ones. They place us back on the true path with greater clarity and certainty. I believe that if you pay careful attention to your pDNA results, you will make fewer *big* mistakes out of the starting gate. You will be much less likely to invest years of energy and thousands of dollars in a misguided effort to create a business you're not suited for.

What if I change my mind later?

Over the years, as you gain knowledge and experience, your pDNA *will* change. That may very well indicate a change in career direction at some point. Fear of changing your mind later, though, is never a good reason not to take decisive action today. Even if your bold choice turns out to be dead wrong, you are better off than if you chose inconsistently or tried to hedge your bets by not choosing at all. In the end, we're all playing the odds. There's no guarantee that by following the Fast Track System you will make the ideal set of choices for you. However, I do believe you'll greatly increase your odds of getting it right.

The path to your ideal business is self-validating to a certain extent. Like meeting a soul-mate en route to matrimony, when it clicks you'll have a *feeling* that you are headed down the right path. Trust your gut

and consult it often. If your early decisions feel wrong or overly stressful, re-evaluate your choices before you go too far. Watch for inner *red* lights telling you to stop, inner *yellow* lights telling you to slow down and inner *green* lights telling you, "This feels right—go full speed ahead!"

The decision becomes infinitely easier when you have clear values that guide your decision-making.

"Choose Your Own Adventure" Time

All right, enough stalling! We've come to the moment of truth. It's time to decide what kind of business you want to run.

At this point you can choose to use the book in one of two ways:

1) If you already have a strong idea as to the type of business you are designed to run, you can flip directly to the chapter that covers it.

2) If you're still undecided, you can read through the next few chapters first, get a little more taste for the two main options, and *then* make a decision. If you go this latter route, take note of how you're feeling as you "try on" the different business models.

CHAPTER SEVEN

The Signature Brand Photographer

"I Wanna Be Like Mike"

Michael Jordan was arguably the greatest basketball player who ever lived. He was certainly the greatest *creator of value* the basketball industry has ever known. Not only did he generate remarkable personal wealth, he simultaneously made himself a cultural phenomenon. He knew intuitively that his potential value lay far beyond his ability to play the game of basketball. He was an entertainer. A role model. A public spokesman. A visual icon. An idea bigger than himself.

In fact, what really propelled MJ to greatness was his realization that his exceptional skill at the game of basketball might actually be *getting in the way* of his greatness.

Early in his career, Jordan seemed able to score effortlessly and at will. He had a mesmerizing effect on those around him. Not only would spectators stare in open mouthed wonder at his acrobatics above the rim, but so would the players on the court. Even his own teammates were often criticized for doing more watching than contributing.

In just his second season in the NBA, Michael Jordan scored 63 points in a single game verses the Boston Celtics. But here's the key fact: his team lost the game. Jordan was "doing everything" himself. Everything but winning.

What happened next set the stage for a new era in basketball. Jordan did something revolutionary. First, he took stock of what he uniquely brought to the table, and second, he maximized his current team situation.

He began to include the other players in the offense. Recognizing the attention he would draw whenever the ball was in his hands, he began to pass the ball at critical moments, leaving his teammates wide open for easy baskets. His teammates began to grow in confidence and carry more of the scoring load.

Then Jordan began investing more time playing defense. The quick-twitch skills that he'd mastered for offense became lethal defensively.

Even though his scoring totals went down, he was still the scoring leader for his team and often for the entire league. He traded modest reductions in his overall scoring for the more valuable prize of maximizing his defense and leading the Chicago Bulls to greater cohesiveness.

The result? No less than six World Championships and unprecedented Superstardom. But his value-adding talent extended far beyond the game itself.

Ever wonder why fashion trends in the NBA went from short-shorts to long shorts? Did you know that all basketball sneakers used to be primarily white? Maybe you've seen pictures of legendary players like Larry Bird and Magic Johnson in their short-shorts and white shoes. Those standard-issue items of hoop regalia were replaced in the '80s and '90s because of one player who, at the time, was playing in those stars' shadows. That player's name, of course, was Michael Jordan.

It turns out that Jordan was superstitious, as many athletes are. When he played college basketball as a freshman, he scored the winning basket to capture the NCAA Championship. Ever since that game, he developed the habit of wearing his "lucky shorts" under his Bulls team shorts. The NBA, at the time, had a rule that players were not allowed to let anything show under their shorts. So what did Jordan do? He ignored that rule and began to receive fines from the league. Finally, he went to his club and asked them to create a longer pair of shorts to accommodate his needs.

Around that time his sneaker sponsor, Nike, decided to create the now famous Air Jordan basketball shoes. In a risky move, Nike and Jordan decided to break even more rules. For the first time in NBA history, basketball shoes were given a primary color other than white. His Nike shoes were black or red depending on whether Jordan was playing home or away games. Once again, the NBA began to fine him.

Guess what happened next? Everyone wanted to "be like Mike." Soon,

every young player in the world had a pair of baggy shorts. Rebel dark sneakers were flying off the retail shelves. The profits from those sales more than compensated Jordan and Nike for the fines.

The copycats began to arrive in droves. A flood of baggy shorts and alternative-colored shoes began to pour from every manufacturer on the planet. People tried to copy his *choices* without having his persona to back them up.

It's interesting to witness the problems the NBA seems to be having in the post-Jordan era. Marketers are still trying to create Jordan-like brands but are missing what he did that was so special. In a recent issue of *ESPN The Magazine,* Jordan himself criticized the NBA for wasting its time trying to emulate his legacy. What the industry needs to do, he said, is identify what is unique about the up-and-coming NBA standouts and create new brands that reflect those distinctions. In Jordan's mind, that is the only hope the game has for stepping out of his larger-than-life shadow.

The Mike I Wanted to Be Like

When Mike Colón burst onto the wedding photography scene, he appeared to know intuitively just how to invest his time and resources. Seemingly overnight he became the name everyone wanted to be associated with. A publishing powerhouse, he was regularly featured in such trendsetting and coveted pages as *Grace Ormonde's Wedding Style* and had more sponsors than he knew what to do with.

He was also the first photographer I'm aware of to publish his day rate as "starting at $20,000." This was over ten times what most photographers were charging. Further, he was the first wedding shooter at the elite level to publicly broadcast his commitment to his religious faith (Christianity). Although this was met with criticism from a few of his peers, his willingness to stand out from the crowd gave colleagues much to talk about. And talk they did.

The now iconic Colón could easily have been lost in the sea of up-and-coming wedding photographers. But he was committed to boldly creating value for the "Mike Colón" brand through leveraging what made him so special. This commitment is also what made him competition-proof and established him as a leader in the industry. And, like the other Mike, that meant that he was not going to let his photography get in the way of the true value he was creating. The real value came from who he was: Mike Colón.

Make no mistake, Mike Colón creates remarkable images. He has a rare gift. But, like Jordan, he realized early on that there are a lot of great players out there and he needed to figure out what he, and he alone, could offer the market. And when he discovered it, he invested everything in those traits that make him distinct.

What were some of his unique characteristics? Well, first of all, by his own admission, Mike has a remarkably high risk-tolerance. This doesn't mean he makes foolish choices. On the contrary, this pDNA quotient identifies an ability to envision outcomes faster than others and comfortably act on that vision. Gifted risk-takers *appear* to be lucky when in fact they are simply skilled in a particular way. Because they can see outcomes quicker than most, they can make seemingly risky moves fast and decisively.

Mike's Attractiveness quotient is also very high. People are drawn to him. Whether it's his physical presence, his disarming personality, or the way he communicates how much he genuinely cares for those around him, the result is the same: People like Mike—and he was wise enough to leverage this talent as a strength.

More could be said about Mike's strengths but it can all be boiled down to one statement. Mike was *made* to be a *Signature Brand Photographer.* His uniqueness was *himself* more than any one thing that he did. He knew intuitively that if he could help others recognize who he was, good things would follow.

How did he do that? Well, on a practical level, he made some risky choices. For example, he spent an enormous amount of money on advertising in his first year in business. As I mentioned before, he was also the first wedding photographer to publish a day rate of more than $20,000. Both moves could have been suicide for most photographers. But for Mike they were the vehicles to superstardom. At the time, there were certainly skeptics who made comments like, "He can't do that— no one's photography is worth that much," and "he's self-taught, he can't ask that kind of money."

Reality quickly nullified those remarks. Mike began booking work around the world and the power of his name gained momentum. Companies wanted to be associated with Mike and sponsorship offers began arriving at his door. That remarkable expenditure on advertising his first year and his willingness to be transparent transformed "high–risk" choices into a wise investment with an outstanding return.

And, what did the rest of the industry do while all this was happening? I know what *I* did. I said to myself, "I wanna be like Mike."

Thankfully, I had the opportunity to become friends with Mike even as he was still emerging. I was able to see that the *surface choices* he made with his advertising, for example, were not the real value he was creating. No, they were only a means to promote himself as a brand. Tragically, too many photographers have made the error of trying to copy Mike's choices rather than learn the real lesson, which is to make *their own* choices.

Like the baggy shorts and black sneakers that proliferated in Jordan's wake, well-intentioned photographers began to buy ads and raise their prices, thinking those choices were the formula for Super-Strength. These naïve moves miss the real value that drove Mike's success. Mike had done the hard work of giving up the focus on photography (like Jordan's sacrifice of mega-scoring) to promote the photographer that he uniquely was.

Colón did other things right too. He allowed associates to handle his non-branded tasks and built a loyal following of photographers and advertising relationships (similar to Jordan's passing the ball and playing defense). He came up with his own marketing mix that was uniquely customized to the brand he was creating. And, in the process, he created a path that only Mike could follow. Copycats would never make it through that hand-cut terrain. That race had already been run. These Mike wanna-bes had their own path to forge, but were missing it by trying to "be like Mike."

And that's the moral of this story: if you're successful at identifying and leveraging the value you uniquely possess, it will be impossible for others to copy it. And, more to the point, if you aren't willing, able or ready to *identify* and *market* the uniqueness that is yours alone, there is virtually no hope of succeeding as a Signature Brand Photographer.

So, What About You?

You may have noticed what seems to be a subtle prejudice in this book. You may feel as if I'm really trying to sell you on the Signature Brand Photographer route. I will admit that I do see a Signature Brand approach as ideally suited for the new Digi-Flat era. If your pDNA supports it, I strongly suggest you give it serious consideration.

That said, I am really not an advocate for a Signature Brand business, a Freelance business, a "hybrid" business, or any business at all, for that matter. But, on another level, I *am* an advocate for a Signature Brand business *if you are a person like me*. If you have the personality and business drive to be a Signature Brand, you will not be fulfilled by going the strictly Freelance route. And vice versa. There are trade-offs and benefits inherent in all of the options. Finding and committing to your true fit is what's key. It all comes down, as I've stressed repeatedly, to your pDNA. You'll only be happy if you build a business that honestly leverages who you really are and what you really were made for.

If you don't want to put your persona in the foreground—and many shooters, by nature, don't—a Signature Brand business is not for you.

I'm very leery to make any blanket pronouncements about which type of business is best for you, based solely on pDNA scores. Only you can make such an assessment, because only you know the full story that lies between the score values. Only you know the particulars of your life circumstances.

As a very general rule, however, high scores in your Self-Starter, Confidence, Experience, Risk Tolerance, Individual Creativity, Self-Promotion and Attractiveness Quotients tend to indicate you might be a good candidate for starting a Signature Brand business. Conversely, high scores in your Program Starter Quotient, along with lower scores in many of the above areas might mean you are better suited to a Freelance career, at least for now.

High or low scores in the other areas might not necessarily point to either a Freelance or Signature Brand career, but they should help you define *how* you choose to build your business *within* either of those categories. Do you want to work as part of a team or alone? Will you focus more on art or enterprise? These questions can and should be asked *within* whichever model you choose.

That said, let's take a closer look at some of the concerns and priorities you'll be dealing with as a Signature Brand Photographer.

Congratulations, You're in the Marketing Business!

The single greatest distinction between a Freelance and a Signature Brand shooter is the actual business they're in. As a Signature Brand Photographer, you must realize that your primary role is not that of photographer.

WHAT?! Then what *is* my primary role?

You are now primarily a marketer. Read that again: You are now primarily a marketer.

This can be a hard pill to swallow but it's one you should try to swallow early and fully if you wish to go the Signature Brand route. It's one of the big reasons why becoming a Signature Brand Photographer is not for everyone. Now, of course, if you choose this career route, you're still going to need to take photographs—and very good ones—but, like both Mikes we've been talking about, you're going to need to identify what value you bring to the table, over and above your ability to execute your craft. And you're going to need to feel comfortable putting the "product" that is *you* out there in the spotlight of the marketplace.

Assuming you're clear on the need to become a marketer, the next step is to understand what your signature value is. That value is going to be your brand. You've already done the hard work of discovering your unique pDNA so you should have some strong clues as to what makes you unique. But there's more to capturing your individual "flavor" as a Signature Brand Photographer than even the pDNA can reveal.

Earlier in the book, I offered a list of questions just to get you thinking about your branded uniqueness. Here are some slightly more focused questions that might help you zero in a bit more:

What is the strongest/most colorful aspect of your personality?
What styles of clothing do you look best and feel best in?
What kind of music do you love? Classical? Rock? Jazz? Celtic? Rap? Is it an important part of your identity?
What style of art do you prefer? Realism? Abstract Expressionism?
What style of architecture and design do you lean toward? Classical? Minimalist? Art Deco?

What decade do you most identify with? '50's? '60's? 70's? 80's? '90's? The present one? Some hybrid of generations?

What defines a celebration for you?

What foods and beverages do you most like and identify with?

Do you have a philosophical outlook that you feel strongly about and want to share with the world? A spiritual identity? Would an overt or more subtle expression of that outlook best reflect the real you?

What are your thoughts about marriage, framed in the most positive way possible?

What culture are you most influenced by? Are you comfortable incorporating those influences in your branded image?

What kind of car best gels with your personality? Restaurant? Magazine? Musical instrument? Musician? Writer?

What segment(s) of society do you feel most comfortable with? Is that the group you wish to market yourself to? What level of education are you comfortable dealing with in others?

How would you describe your ideal client? What sorts of activities is this person involved in? What kind of products does she or he buy? What publications does he or she read? What places does she or he frequent?

Which celebrity's public image are you most attracted to? Why? Do any of those qualities apply to your own brand? If so, how? And how are you uniquely different?

What indefinable quality do you possess that makes you bigger than the sum of your parts?

Even though some of these questions may seem distant from photography, they are meant to get you thinking about the "spice" you can season your brand with. Honest and creative answers to these questions, in combination with your pDNA results, should give you some great ideas.

As you're doing the creative work of defining your brand, ask yourself: Do I do this kind of creative work best in isolation or in collaboration? Should I take a few days away by myself or hunker down in my favorite work space? Or would I benefit from joining a small group of fellow business-starters who brainstorm with one another?

Whatever means you use to arrive at your brand identity, you'll need to clearly identify:

Your target client
Your brand's dominant "message"
Your identifiable style
The unique "hook" that distinguishes you from others that might be seen as similar to you
Your authentic value as you deeply know it
The "solution" you offer the marketplace (more on this below)

I've Got My Brand; Now What Do I Do with it?

Once you have a sharper picture of your best "you" and your ideal client, you will begin to get many ideas as to how to creatively market yourself. For example, are you an alternative-styled rock music-lover who

wants to target hip, urban young people interested in non-traditional weddings? Are you a "country estate" type with a Martha Stewart-like aesthetic who wants to target families of Ivy-leaguers?

Whatever your brand identity is, you'll need to ask some general questions, such as:

Where should I establish my business presence (both in cyberspace and in the brick and mortar world) to get maximum exposure to my target audience?
What kinds of publications might I advertise in (if I choose to advertise) to target my ideal client? Think creatively. Guitar magazines? Horsemanship magazines?
What kind of haircut should I get? What kind of clothing should I wear? Do I want my style to be shared by my assistants or do I want them to play against me?
How should I present myself when meeting clients in person? When shooting events?
What style of graphic art should I use in my marketing materials?
How do I plan to incorporate my photography style with my brand?

As you are working this out, you'll need to consider how important it is to establish your credibility in the eyes of your colleagues. It's hard for me to imagine a Signature Brand Photographer who isn't known in his/her own industry. Pragmatically, this is important since brides increasingly will do Google searches to check out what your colleagues say about you. If you don't show up in search engines, how branded could you be? If you're relying only on Search Engine Optimization (SEO) to direct attention to yourself, you're going to come up short. You need the help of your friends to make it as a Brand Name.

I Don't Want to Sell Anything...

In the 1989 generation-defining film, "Say Anything" the super cool lead character Lloyd (John Cusack) has a high school love interest, Diane (Ione Skye). In a pivotal moment, Lloyd is being grilled by Diane's father (John Mahoney) as to his career aspirations and declares:

I don't want to sell anything, buy anything or process anything as a career. I don't want to sell anything bought or processed, or buy anything sold or processed, or process anything sold, bought or processed or repair anything sold, bought or processed. You know, as a career, I don't want to do that.

One of the reasons this line helped transform this low-budget teen movie into a cult classic is because it resonated so deeply with the universal desire to be genuine and to not compartmentalize one's life. If you're like me, it just feels truer to be the same person at work as you are in the rest of your life.

My interpretation of this moment in the film is that Lloyd was declaring that he was going to be true to himself, regardless of the commercial viability of his chosen career. He was basically saying that he would rather be poor and honest than a rich sell-out.

He was not condemning *all* sales activities, in my opinion, but one particular form of selling, namely the art of manipulating people to buy things they don't really need.

When it comes to photography, or any service based industry, the Digi-Flat era is thankfully bringing an end to such old-school sales techniques. Because of the ever-increasing power of consumers to grade and compare service providers online and because of the transparency of the Internet, misleading people into buying second-rate services will not get you very far. This is good news for consumers, but it presents some fascinating challenges for marketers.

For example, how does one generate business, experience and cred-

ibility at the beginning of one's career in the Digi-Flat era? Even if one wanted to, can one "fake it" and really believe they will "make it" in the long haul?

Acting as if you're successful before you actually are is certainly an understandable approach if you want to create something out of nothing. But in our transparent, Digi-Flat era, this phony method will eventually hurt you more than help you. Not only is faking it an unpleasant, dishonest experience, but the world is growing savvy. It has the tools to check you out.

Don't Sell It, Solve It

I would argue that a new day has dawned for "salesmanship" in the Digi-Flat era. It's a move away from hawking things and a move toward casting yourself, the seller, in the role of problem solver. It's a subtle shift in thinking that lets you leverage who you are *right now* as a photographer (your pDNA).

When you position yourself as a solution to a problem, your newness to the industry can actually become an asset rather than a liability.

How? Well, let's think about the rock 'n roll photographer I postulated not long ago. How might he represent a solution to a problem? Well, as I said, he wants to target a young, hip urban clientele. When he surveys the "competition" in his area, he sees mostly middle-aged, mainstream photographers with hokey, confectionary styles. Confetti, lace, champagne glasses. Ho-hum. His brand's message, then, becomes a direct answer to that "problem." He announces, through all of his marketing efforts: "I'm the new kid on the block. I *get* you in a way those other guys can't. I'll give you a service that's clever, edgier and a lot more fun than those "traditional" photographers. And I'll do it in an aesthetic you and I share."

For the photographer with the "country estate" flavor, the problem to

solve would be a different one. For example, she might position herself as the antidote to the glut of second-rate, fast-buck wedding photographers who don't understand the tastes and aesthetic requirements of an upscale clientele. Her branded message might be, "You're safe with me. My tastes are impeccable; I won't let you down."

Whatever you have identified as your core value, odds are it represents a solution to *someone's* problem, even if they are not aware they have a problem (as a marketer, it's your job to point it out). And odds are, the "someone" whose problem you can solve is exactly the client you're hoping to serve.

Being a problem-solver, in effect, gives you a gateway to be new at the business. It's as if you're saying, "I looked at the competition and decided I *needed* to get in the game to offer something better."

On a personal level, this adjustment from hawker to problem solver not only allows you to retain your personal integrity—no small benefit!— but gives you increased confidence about the objective value you offer to the customers who will now seek you out. Plus, as an added bonus, it works!

From Prospect to Pursuer

Imagine what your professional photo life would be like if you could just wave a magic wand and transform "prospects" into pursuers of you instead. Not only is such a wand available, I believe it is the only viable way to sell non-commoditized goods and services in the Digi-Flat era. It is, I suspect, the only approach that will now work with any sort of effectiveness over the long haul.

The principle is simple: If you offer genuine value, then someone out there wants or needs it. Your job isn't to bait and chase these people, only to communicate who you are to them. Then they will come to you—thrilled to have found you.

That's not to say there isn't work involved. There is. But the labor has more to do with putting yourself in front of your future customers when they're ready to buy than pitching and persuading them. As a Signature Brand photographer, you simply make available the option of working with you and you do so in an intelligent, cost-effective way.

Be Prepared to Remodel

Before you put yourself out there, though, you may need to do a little remodeling.

What does a *remodel* look like for you? Well, it depends on the "house" you've lived in until now. A young photographer, for instance, once asked me for advice on how to go from unknown hobbyist to Signature Brand Photographer. He had some unique characteristics that I thought could be shaped into a very attractive brand...with one powerful exception. He wore really thick glasses. And, like Simon Cowell on American Idol, I felt compelled to point this out.

I don't think I was being cruel or mean. Quite the contrary. The fact was, I didn't believe he had any hope of becoming a Signature Brand Photographer when the first impression he made on people was that he couldn't see! I told him that a true remodel meant he needed to lose the glasses. At first he was hurt. But he very quickly realized the obvious truth and couldn't believe he hadn't noticed it himself.

A remodel can be painful but absolutely necessary if you're carrying any personal baggage that's going to get in your way. This can include, but is not limited to:

» Speech patterns

» Facial expressions

» Physical "quirks" that can be altered

» Social skills

» Telephone manners

» Presentation skills/ability to talk to a group

» Writing skills

» Hygiene and grooming

» Energy level

» Moods and attitudes (and ability to control them)

» The people you associate with

» Personal habits

To his credit, my bespectacled friend was sharp enough to know that it would be even more unattractive to his clients if he tried to *fabricate* a remodel that didn't flow from who he was. His remodel had to flow out of his real person. In the same way that a home remodeled to fit a fad always looks worse and worse over time (i.e. a Victorian home with a '60s kitchen), so too does the photographer who does not remain true to himself/herself. In contrast, have you ever been to a home built in the '20s, '30s, '40s, etc., that stayed true to its era even through a modernizing overhaul? These places have timeless appeal.

What's great about my friend is that he did stay true. The glasses got ditched but his style didn't. In fact, the more he drilled down into himself the more he discovered his passion for an entirely different genre of photography beyond weddings. Mission accomplished.

Everyone's World is Flat—Be Known for the Right Reasons

As Thomas Friedman points out, the world is flat for *both* the good guys and the bad guys. Whether you're Bono or Bin Laden, Superman or Lex Luthor, everyone is free to leverage our Digi-Flat times to the best of their ingenuity. It's not called a "level playing field" for nothing.

Despite my warnings, you may still be tempted to fabricate a persona

and try to leverage it through our Digi-Flat world. Let me be very clear: this will not work. If you go down this road, you may experience a short-term burst of notoriety but that will soon turn on you and you will become known as someone who is not authentic or a value creator. Job One is not to *falsely* self-promote.

Job One is to find your *true value*. Job Two is to unapologetically put that true value on display for others to appreciate and to appropriately compensate. Your uniqueness comes from your authentic value, not from a phony characterization.

Putting your true value on display is the creative part. It's only fun, though, if you are crystal clear as to what the backbone of your value truly is. I learned this lesson the hard way. Recovering from this poor choice was possible for me only through eating great quantities of humble pie. You can avoid this by being completely truthful from the start.

As a branded service provider you *must* stand out from the crowd and that means making yourself known. Before you even start down this path, though, you need to honestly ask yourself *why* you want to become a known photographer. Do you want to create value through your work or do you just want to be "known"? What's your honest truth?

The great acting teacher Stanislavski cautioned all would-be actors to "love the art in yourself, not yourself in the art." I would offer the same advice to fledgling Signature Brand Photographers. Many of us got into this gig not because we wanted to be known, but because we love the medium of photography. If, at any point, you begin to lose that *primary* motivation because you are spending too much time promoting yourself, I encourage you to pause and regroup.

In fact, I recommend that you put in your calendar right now, before you even get started building (or re-building) your business, an annual personal retreat to reassess all the things we address in this book and all of the choices you have made so far. My friend David Jay calls this his

annual "why" retreat. We all need to re-calibrate if we are to stay true to our greatest value and to ourselves.

The 80:20 Principle and You

Becoming a Signature Brand Photographer is harder than many shooters appreciate. You simply have more concerns to worry about than your Freelance friends. There's no way around it. The payoff can be greater but so is the risk. It's crucial that you understand the 80:20 principal and how it relates to building your Signature Brand business.

If you've been reading this book from the start, this is not exactly new advice, but it bears repeating in stark numerical terms: 80% of your work needs to be accomplished with 20% of your energy. If you're not deliberate and intentional with this, you'll soon be spending much of your prime 20% on the wrong tasks.

My suggestion is that you write down *all* of the tasks, large and small, that go into running the photographer business you envision. Rack your brain and put down every chore you can think of, from advertising to shooting to cleaning the office to paying the utility bills to mailing out the wedding albums. Then create two lists from this. The first is your "20% List." This includes all of things that you, personally, should be doing—the things that *require your touch* in order to add value to the brand. The second is your "80% List." This includes all of the work you will soon be farming out in one way or another. The classic temptation is to put too much on the first list and too little on the second. Keep reworking it until you've reached the golden 80:20 ratio.

Now become intentional about organizing your business, as quickly as practically possible, so that you are doing only these activities. Your job is to always keep the "20% List" to a minimum and to keep taking things off it as you build the infrastructures to carry out the "80% List."

There's another version of the 80:20 principle that applies equally as

strong, no matter which business model you choose to follow. That is, as a company, focus 80% or more of your energy on capitalizing on your strengths and only 20% or less on improving upon your weaknesses. At least 80% of the day-to-day focus of a wildly successful business is on increasing the things it does amazingly well, those things that add value in the world. 20% or less of the focus is on patching up deficits.

Make your business about maximizing your added value—not about competing with anyone, emulating anyone, looking over your shoulder or trying to capitalize on trends—and you'll be a Signature success!

CHAPTER EIGHT

The Freelance Photographer
(and Other Career Opportunities)

Becoming a Freelancer with a Smile on Your Face

The simple truth is that shooting for a fee is much easier to pull off than establishing a Signature Brand. There are fewer business considerations and fewer balls to juggle in the air. The barrier to entry is also lower and it's much easier to learn as you go. And, as icing on the cake, you typically get paid fairly generously for your time and talent.

Some of the obvious relief you will gain by going the freelance route include:

» Someone else meets with customers and makes the sales

» Someone else books and schedules the events

» Someone else takes the bulk of the business risk

» Someone else is responsible for ensuring profit and avoiding loss

» Someone else does the marketing and advertising

» Someone else pays the salaries and manages the staff

» Someone else absorbs most of the office overhead

And while "someone else" is doing all of these things, you are freed up to do such things as: take on more paid photography gigs, work a second (or first) job, further your education, pick daffodils, work on your spec photography (photos you intend to later sell or publish), spend time with your family, or build a Signature Brand business at your own pace.

Working as a Freelance Photographer is an ideal choice for those who just love the craft of photography but don't want all of the accompanying headaches. And if you have commitments beyond photography, this career path could give you just the flexibility you need.

Sure, the market will define how much you can make, but the volume of work available will only increase in the future as the number of fee-based companies rise and your reputation as a dependable shooter solidifies.

Yes, the companies that hire you will reap the financial rewards that

come with running a scalable enterprise, but they will also take all of the financial risk. Many of these companies will not survive. You, however, will be able to easily find work again by remaining light on your feet.

Signature Brand shooters do get the glory of being famous within their industry, but the market is also more fickle toward brand names. Like actors or musicians or clothing lines, this year's hit could be next year's forgotten player. Brands fall in and out of style with alarming rapidity. By going the non-branded route, you may not become a household name at tradeshows, but your photography persona won't rule your life either. Many Freelance Photographers live a glorious and anonymous life. They retain their passion for photography precisely because they are the captains of when and where they shoot. If they want to make a little extra money, they make themselves available to shoot for established brands. The payoff is less but so is the risk. And, what the Freelance Photographer gains in terms of freedom and flexibility is often worth that trade-off.

Just Remember...

Opting for a Freelance career is a trade-off, as is every choice you make in life and business. The shooters who remain happiest on the Freelance path are those who accept this trade-off with eyes wide open, fully aware of what they are giving up and what they are gaining. (By contrast, those who slip into Grumpiness are often those who fail to take conscious stock of the pluses and minuses. They then proceed through their careers with resentful, entitled attitudes, feeling unappreciated and undervalued.)

Here are some of the "negative" considerations you should be fully and happily aware of, should you tread down the Freelance road:

>> Someone else is going to make a profit on your work

>> You may lose your rights to the photos you produce—your images may

be altered, packaged and publicized in ways you might not approve of

» No matter how many copies are sold of your images, you make no additional income—you're a "work for hire" employee

» You are "at the mercy" of a market you do not control; how much work you manage to get at any given time is not entirely up to you

» Excellent work is not directly rewarded more than merely adequate work—the external incentive to excel is not as sharp

» You may need to follow shooting guidelines and style considerations you find personally distasteful

» You may need to take criticism from "bosses" who know less about photography than you do

» You will never become known as a superstar

» You will not fully shape your own career; rather you must dutifully adapt to the changing requirements of the marketplace

If you are crystal clear on who you are, what you're giving up, what you're gaining, and what you want to be about, you can happily choose to do Freelance work throughout your career on a full-time, part-time or even occasional basis.

Your Value Is Different as a Freelance Photographer

It's important to understand that, as a Freelance shooter, your value as a photographer is qualitatively different from that of a Signature Brand shooter. Of course, it goes without saying that for both business models, you must take excellent photographs and be proficient at your craft. But in at least one major way, your essential value is almost *the opposite* of a Signature Brand Photographer's. Here it is in a nutshell:

The branded shooter's job is to get noticed. *Your* job, as a Freelancer, is to remain "invisible."

What do I mean by this?

Well, think about the reasons anyone hires an employee, contractor or subcontractor. Essentially, they want some work carried out with the least amount of time, attention and trouble for *them*. If they have to put too much energy into the job, it's easier to do it themselves. Employers want hired work to be done dependably, at a high quality level, with the least amount of involvement on their end—before, during and after the job. The more trouble you require as a contractor/subcontractor, the less value you represent to employers. It's that simple. That's what I mean by being invisible.

In the case of wedding photography, that means:

Before the Event

» You are easy to reach and return phone calls promptly

» You are regularly available for gigs and don't refuse gigs *too* often

» You don't work for too many employers; you don't play one employer against another

» When you must turn a gig down, you do so cleanly, politely and gratefully, without drama or promises of "I'll see what I can do and get back to you."

» You *accept* gigs cleanly, reliably and maturely, without having to be "persuaded" or "sold"; you don't leave employers hanging

» You don't call employers back repeatedly with a lot of questions— you gather all of the information you need to shoot your event quickly, efficiently and politely in one phone call

» You project an attitude of service and gratitude for the opportunity, not one of "I'm doing you a favor; what's in it for me?"

» You stick to all of your agreements; you never cancel out on a gig you've accepted unless it's for a dire emergency

During the Event

» You never, ever fail to show up for an event you've committed to

» You always show up on time

» You bring all of your equipment, plus back-ups

» You maintain a thoroughly helpful, professional and service-minded attitude throughout the event; you represent your employer well

» You work hard and get all the shots required, with no excuses

» You don't have any "special requirements" that the company or client must adjust to

» You treat all event attendees with respect, even if they're obnoxious, emotional, or have had too much to drink

After the Event

» You deliver an excellent, professional product that does not generate customer complaints (customer complaints are the worst after-event headaches)

» You don't hound the employer for more work; an occasional "stay in touch" email or postcard is fine

» You wait a respectful amount of time before checking on, or complaining about, your payment

» You don't seek praise for your work, either directly or indirectly

» You never ask for more money than agreed upon or seek to change the original agreement

» You thank your employer for the gig and for the payment, once it is received. A brief email, with no response required, is sufficient

As a Freelance shooter, *not* trying to be noticed will go a long way toward getting you noticed in the right way for the right reasons!

Your Uniqueness in the Freelance World

Does this mean that when you become a Freelance shooter, you must be a faceless, persona-less shooting machine whose only value is in the product you generate?

Not at all.

It's simply a question of emphasis. In the Signature realm, your photography is very important, but remains subservient to *who you are* as a photographer. The emphasis shifts in the Freelance world: your individual value is important, but remains subservient to the product you are providing. Both product *and* persona are important in both arenas, but the primary emphasis shifts.

In the Freelance world, you still bring unique value to the table by means of honoring who you authentically are. I talked about this a bit earlier in the book. If you are comfortable in the realm of riding stables and private yachts, for example, and have well-honed classical tastes, by all means bring those qualities to the fore when you are doing a high-end wedding where these qualities add value. Clients will appreciate your special touch and you will gain a reputation amongst employers as the "go to" person whenever an informed, elegant approach is needed.

If you have a knack for getting people to laugh or relax, or have a strong sense of landscape composition, use it whenever you see an appropriate opportunity. Any personal trait or photo talent that adds value to the job you're doing should be expressed, not suppressed or denied. Again, by gaining a reputation as someone who, for example, can get guests to loosen up or has unusual sense of spiritual sensitivity, you will be called first whenever such talents are needed on a particular gig.

Bella Pictures, on its website, claims to make strong efforts to match the right photographer with the right client and event. This will undoubtedly be the tack many fee-based employers will take in the future, as they try to gain customer buy-in. So how do you become that "right"

photographer more of the time? Not by suppressing who you are, but by bringing it out whenever it adds value.

But, of course, you must do this with the understanding that the photo shoot comes first. Therefore, if your uniqueness does not add value, keep it appropriately in check.

Finding Work

One of the great benefits of being a Freelance shooter, as we noted earlier, is that you don't have to spend much money on advertising and marketing. That means you can just sit back and wait for the paid gigs to roll in, right? Sadly, no. Until you become such an in-demand shooter that you're literally turning jobs down, you may have to invest a good deal of energy, time and, yes, money in drumming up work for yourself. As independent contractors in many fields quickly discover, the freelancer must often spend anywhere from ten to forty percent of his/her work time *looking for new work.*

As a photographer, by far your greatest source of paying gigs will come from the professional network you create and from the employers you serve dependably, skillfully and cheerfully. Do a great job and you'll be hired again and again. You may soon find that you have a steady enough flow of work that you don't have to actively seek gigs anymore. But when you're starting out, and from time to time throughout your career, you will need to "beat the bushes," seeking new work with new employers.

Fortunately, our Digi-Flat times make it easier than ever for you, the skilled professional, to hook up with people who need your services. The main way to do that, of course, is via the Web. Job contracting sites have become the primary way employers seek not only full-time help but short-term contract work. Many of these sites work in two ways. They allow you to: (1) post a professional profile so that employers can seek you out and (2) scroll through available opportunities and contact employers yourself.

The list of great freelance work sites is always changing and growing, so it's not possible for a print book to accurately and completely capture all the existing opportunities over the long term, but here are several sites that were running as this book went to print.

» Guru (guru.com)

» Elance (elance.com)

» craigslist (craigslist.org)

» MySpaceJobs (jobs.myspace.com)

» Mediabistro.com (mediabistro.com)

» PhotographyJobsCentral (photography-jobs.creativejobscentral. com)

» indeed (indeed.com)

» All Freelance Work (allfreelancework.com)

» jobfox (jobfox.com)

» iFreelance (ifreelance.com)

» JournalismJobs.com (journalismjobs.com)

» Sologig (sologig.com)

» GoFreelance (gofreelance.com)

The Role of Second Shooter: Partner, Network and Learn

Over the course of your wedding photography career you will probably have the opportunity to serve as a "second shooter" from time to time. That means you'll be assisting a primary shooter, usually for a set fee (or some-times as a mutual favor). Even if you are an aspiring Signature Brand Photographer, this may be a welcome opportunity to experience the Freelance model first hand. Assuming you're fine with this arrangement and see the value in it, what's the best way to approach the second shooter role?

The main thing is: be a partner, don't "assist." The best second shooters I've ever worked with weren't just helpers. They were true co-shooters. They actively supported me and supported the job, *anticipating* upcoming tasks and potential problems, rather than waiting to be told what to do. They were in it 100%. I think that's why I prefer to invite seasoned pros, who are less tempted to draw inappropriate attention to themselves, to partner with me on weddings and why I love to return those favors.

Whenever you "second shoot," you should be thinking beyond the day. The goal isn't simply to shoot for shooting's sake. The goal is ultimately to learn and to network with the first photographer (not the other vendors!). The trick is to do so in a way that doesn't show.

Learning should always be a prime motivation for second-shooting. Each second-shooter gig is like taking a lab course in real-world photography. Whether the person you're assisting is higher, lower or equal to you on the "photographer food chain," you can always learn something new. Maybe it's an improvised way to diffuse light, maybe it's a mental trick for helping remember the names of wedding guests— there's almost always something that this particular shooter has learned that you haven't tried. Of course, there's more to learn from pros who are more experienced than you, but don't let pride get in the way of learning from anyone—even if you only learn what *not* to do.

As for networking, the key is to know your place. Recognize whether you are networking *up* or networking *across*. Networking up means exposing yourself to someone with greater leverage in the industry than you. You are there to help them exclusively. You're building goodwill in the process and you're learning like mad. Part of your goal, though, should also be to move from networking up to networking *across*.

Networking *across* is more like helping out a peer or adding brand value to their client's experience. For example, I recently second shot a wedding for Jessica Claire in Las Vegas. Mike Colón also came along (I kept joking with him that he was third-shooting).

Jessica had a narrow travel schedule between the three weddings she was shooting that week. Since we were both free, she asked Mike and I if we'd be willing to come to Vegas a little early just in case something went wrong with her flight. In this way she was able to assure her client that even if the worse case scenario happened, there was enough photographer value at the wedding to make up for unforeseen circumstances (apparently Mike and I equal one Jessica).

Not only was this arrangement smart for Jessica—it was smart for Mike and me too. As he and I were making a "relational deposit" with her, she was able to make a "confidence" deposit with her client. Since it wouldn't make sense for Jessica to hire Mike or me at our day rates, we volunteered our time in exchange for Jessica covering our expenses. Best of all, we got to hang out and shoot at a fun, relatively stress-free wedding. Also, since it was crystal clear that this was Jessica's wedding and not our Signature Brand responsibility, Mike and I were afforded some freedoms. As long as we served Jessica first, it opened up the opportunity for creativity and alternative shooting ideas for us. In the immortal words of Michael Scott from *The Office*, "It was a *win-win-win* situation."

Going the "Hybrid" Route

Is it necessary to choose one path over another? Signature Brand vs. Freelance?

As I have suggested from time to time already, many photographers will discover that their unique route to happiness and success, based on their pDNA, comes from cobbling together a custom blend of both models.

If you have a Signature Brand business, the occasional Freelance gig can be a welcome relief, a chance to shoot without all the added worries and responsibilities. If your income is derived largely from the Freelance model, having at least one arena in which you establish a

signature name for yourself can provide meaning and motivation. This might include, for example, shooting stock photography, doing commercial work or showing in galleries, restaurants or gift shops.

The main thing to keep in mind if you're going to play both roles is always to remember which role you're playing. Like a graduate student who has to play teacher part of the time and student part of the time, the key is to always know which hat you're wearing. Don't bring your Signature Brand shooter status (and ego) to a Freelance gig. You will only annoy and alienate people. Your role is employee, not central figure.

Conversely, don't forget that when you *are* hired on a Signature Brand basis, you're expected to bring a certain presence to that role. You can't "mail it in," you've got to live up to your brand. Everything you do when you're wearing your Signature Brand hat is sending a marketing message to your clients and prospects.

Opting to Remain a Non-Professional

It's quite possible, of course, that after considering your pDNA and the business models I've laid on the table, you will decide professional photography is not your thing after all. If so, I applaud you for making that honest appraisal. The truth is, professional photography is *not* for everyone; it isn't even for all gifted photographers.

Some of us will remain happiest if we always pursue photography purely out of love. Introducing money to the mix can muck it up.

I know of one man, for example, who works as a corporate attorney for a major law firm. Nearly every weekend, he spends at least part of his time prowling around the harbors near his home, taking brilliant, artistic photographs of boats. His photography is extremely important to him and could probably win him awards and magazine assignments. But he doesn't even casually entertain the notion of going pro. He likes things just the way they are. For him, photography is a meaningful, non-verbal

way to escape the high-stakes, word-filled world of corporate law.

Another person I know recently told me about his daughter, who is a gifted artist. She made the conscious choice not to pursue art as part of her college curriculum. She felt that "taking it apart" and becoming too analytical about it would sap the joy from her experience and cause her to second-guess her natural instincts. She preferred to keep doing her art for love instead.

There are many good reasons for not becoming a professional. Love is probably foremost among these. If you feel going pro is going to interfere with your love of photography, then I'd recommend giving the career a serious re-think.

The fact is, going pro *will* test and strain your love of photography to some degree. Many people who start out in a creative career such as writing, art, photography, or acting find that they're so happy to get paid for what they love, they happily gobble up all the paying gigs they can. Years later, they've become hacks, cranking out the work for money, but no longer really enjoying it. The passion is gone; it's become a job.

I remember, for example, seeing an interview with an actor who became known for playing a certain running character on TV commercials. Though he earned a good living (he made hundreds of these commercials over the years) he became so locked in this role in the public's mind that he couldn't get any other work. For decades all he did was the same character for the same company's ads. Over and over. He was grateful for the steady work, but you had to wonder: is that why he became an actor in the first place? To hawk junk food? Probably not.

Some of us can maintain our love of photography even as we do it for commercial exchange, others can't. It takes a special kind of person, I think, to hold onto the love while fully leveraging the entrepreneurial side. If you are not this type of person (and you may need to experiment a bit to find out) I recommend staying a non-professional.

Notice I did not used the term "amateur." I prefer to use the term "non-professional" for those who choose not to trade their services for payment. It's a non-judgmental term and I use it that way.

The term *amateur*, if you'll recall, I reserve for "higher" purposes.

I sincerely hope you will cling to your amateur status for your whole career. I hope you "stay in love," so to speak, and don't just remain married for the sake of the kids. If you're just starting out, make a vow right now that you won't let that happen. If you're a jaded professional who has "lost your way," I urge you to re-claim what is rightfully yours: that primal love of photography that put a camera in your hand and wouldn't let you put it down.

Be an amateur forever. There are enough Grumpies in the world already.

In the next chapter we're going to take a look at some "global" considerations—ideas you'll want to keep in mind, regardless of whether you're doing a Signature Brand, Freelance or hybrid business.

CHAPTER NINE

The Business of Being a Photographer

The Tragedy of Being Trained

It's not really fair to indict places of learning, art schools in particular, for failing to train their students to be professionals. That's not what they're there for. They exist primarily to teach the art and craft of photography. The tragedy is that many students who graduate from those schools fail to make the distinction between the skill and the person *exercising* those skills. They don't know the difference between who they are and what they do.

Many of my friends are professionally trained. As a largely self-taught shooter myself, I occasionally feel twinges of jealousy about the gift they've received. Thanks to their training, they see the world and their equipment in a more sophisticated way than I ever could on my own. When I've asked them whether they ever received training on *who they are* and how that might inform their professional lives, though, I usually get blank stares in return. At best, they tell me they did take one elective course on "the business side of photography."

These fine people have spent tens of thousands of dollars to attend respected "professional" schools in the art of photography only to be left bankrupt in the skill of being a photographer. There's even a "purist" mentality in many of these institutions that works *against* positioning students to win in the marketplace. It's as if learning how to sell yourself is equated with selling out. Floundering in the wake of this mentality are thousands of highly trained and under-employed photographers, many of whom will not even be shooting for a living in the very near future.

These artists believe that since they're trained to take pictures they must be in the Photography business. Of course, as I've gone to great lengths to emphasize throughout this book, they're not. They're in the Photograph*er* business and nobody (before now) told them so. With that distinction clearly in focus, let's tackle some practical realities about being a business owner.

You Are Now a Business Owner

Unless you are a full-time employee of a photo studio (a perfectly legitimate career choice, by the way), then if you want to earn a living with your camera, you must now step with both feet into the arena of *business*. Sorry, but that means all the purist considerations you picked up in art school may now officially be placed on hold. At least for the time being. Even if you plan to focus only on the *artistic side* of photography, you still need to become a *businessperson*. Or else remain a hobbyist forever.

Whether you're a Freelance shooter who wants to minimize your involvement in the customer-generating aspects of the craft, a Signature Brand shooter who plans to hang out your own high-profile shingle, or something in between, the moment you accept your first check, you have officially become a small business owner. Yes, even if you're strictly a Freelance shooter who only shoots for others on a contract basis – you're still a small business owner. So you'd best be sure this is what you really want.

Most of us understand the motivation for transitioning from employee to small business owner: work your own hours; keep all the profits; control your own destiny; get out from under the thumb of "The Man." Right?

Well, if you've ever made that shift yourself, you recognize the pain such a move can cause. The benefit of being an employee is that the company takes care of a lot of unseen problems. Employees tend to be fond of griping around the water cooler but rarely appreciate how hard it can be to make everything work in a company. When those folks jump ship and start their own ventures, reality kicks in. It's one of the reasons so many startups fail.

Though this chapter is not meant to be a nuts-and-bolts primer in how to set up a small business, there are some universal considerations we ought to discuss before you set sail on the seas of commerce. These

considerations apply, to a greater or lesser extent, to all Photographer businesses, regardless of the model you choose.

Start-Up Blues

I remember taking a $3000 business loan from my mom when I first began. I figured this princely sum would cover me for a basic camera setup, which was all I thought I needed. The funny thing was, I actually believed that I would not need to spend any more money, ever, on my new photo business.

Naiveté is the first casualty of the new business owner.

Once I spent my startup fund, I thought I would be so dialed in I'd just be collecting checks from that point on. Trouble was, I didn't even know what to *do* with those checks.

After I booked my first wedding for $1500, I went to the bank to open a business checking account. To my shock, I was denied. The bank manager said they literally wouldn't let me deposit money. They said I needed a DBA. A DB-*what*? I finally figured out that DBA is an acronym for "doing business as." The banks needed to know I was a legitimate business. One way to prove that, in the city and county I lived in, was to take an advertisement in the local paper and publicly declare my business intentions and my business name.

While that ad was running, I needed to get my city and state business licenses. Licenses? Who knew? When the bank finally let me open the checking account, I realized I had no system for keeping my books. None. I am a horrible accountant. Hmm, maybe I needed to hire one. Friends told me I should consider incorporating to save on taxes. Incorporating? Taxes? Oops, forgot about taxes. My employer had always deducted them from my paycheck. I guess I needed to pay them on my own now. Maybe I needed a tax guy, too.

Not to mention an attorney to help me with my contracts and a consultant to help me with my business plan...

As I planned the shooting of my first event, I realized I didn't have redundant equipment or a plan to back up the images I intended to shoot. All of a sudden my $3000 loan was being stretched like a rubber glove over a bowling ball. It needed to cover about a $10,000 budget!

I hadn't shot my first wedding yet and I was knee deep in stuff I was "supposed" to do.

As I began running about getting these things in order, I realized I had no idea what to attend to first. I had left the naïve stage and entered the confused stage. I had just enough information to be dangerous and not enough to make good decisions.

My point here is not to give you a blow-by-blow list of all the tasks that *should* be done in order to build the perfect business. That will vary depending on where you live and the kind of business you're starting. The point is that you need to do *some* research and *some* organization up front. This part is not fun or inherently rewarding, but it must be done. The more organized you are *going in,* the more enjoyable the actual work of running your business will be.

Thanks to incredible resources like Start-Up Nation (http://startup-nation.com), we don't need to reinvent the wheel. Nor do we need to cover all the specifics here. The order and priority of what you should attend to probably should change depending on whether you are setting up shop as a Freelance Photographer or as a Signature Brand Photographer. But if you are serious about wanting to go pro, you need to take care of these realities sooner rather than later.

As you get organized, I again advise that you develop only a basic working knowledge of most of your routine business tasks and no more. Don't get caught up in them. Keep your overall vision focused on the forest, don't get lost in the trees.

Please know that a live, up-to-the-minute set of concrete, real-life suggestions is available 24/7 in the *Fast Track Photographer* commu-

nity forum. It's here that I and all the members can help you discover how best to accomplish your specific business needs. And, better yet, we can *discuss* those ideas together rather than just have a one-way monologue. Again, to access this resource, check out http://forums. fasttrackphotographer.com.

I'm so excited about this forum. I think this resource alone could save you literally hundreds of hours of needless work. It should give you comprehensive help in all the non-negotiables that you need to address.

That said, below are some of the "universals" you'll want to be on top of if you're starting and maintaining a Photographer business.

Getting Organized

Your Digital Assets

- » software such as Lightroom/Photoshop is working and up to date

- » you have decent working knowledge of all your software

- » you have a clean and sensible system for organizing your computer files, including your photos; you can find anything you need on your computer(s) within seconds

- » your email accounts and signatures are set up in a professional manner

- » you have an email domain name that looks businesslike rather than personal (i.e. tsmith@yourbusinessname.com, rather than foxydogg376@aol.com)

- » you have a reliable, routine file backup system

- » you regularly back up digital archives off site (in case of fire or natural disaster); you store these on DVDs in a fire-safe location or use an online file backup service

Your Photo Equipment

» all your gadgets and accessories are working, well-protected and well-organized

» your camera is of the highest professional grade you can practically afford

» you have equipment redundancies in case of failure

» you're not missing any key piece of photo equipment that will enable you to be competitive in your particular business

» you've actually read all of your instruction manuals

» your carrying cases look professional and are in good condition

Your Relationships (in the Community, Online and In Person)

» you don't owe anyone work, money or correspondence

» you've made peace with anyone with whom you've had a misunderstanding; you don't have any "uncontained enemies"

» you have a system in place for handling routine client communications; you can and do return client phone calls within 24 hours

» you've created a system for regularly keeping in touch with clients and other important people—newsletters, email updates, automated self-reminders—so that no one "drops off the map"

Your Money

» you use software such as Quicken or Quickbooks to automate and streamline your accounting tasks—or better yet, hire a bookkeeper

» you have a clear, auditable, record-keeping system for all your income and expenditures

» you save expenditure receipts in an organized way

» your taxes are in order and you have an accountant or tax software to handle them

» you have a plan in place for speedily repaying any "informal" business loans you may have incurred (from family members, friends, etc.)

Your Bank/Banker Relationship

» you have a business account that's not entangled with your personal accounts

» you have a business credit card

» you have a line of credit on your bank accounts

» you have good relationships with a local bank and its personnel

» you have a good credit score or are intentionally working on improving it so that you can borrow if necessary

Your Business Model Identity and Legal Life

» on the heels of working through this book, you have written a business plan that fits you uniquely

» you have determined the kind of legal entity you wish to be (sole proprietor, S-corporation, LLC, etc.) and have filed all of the paperwork necessary

» all local and state vendor licenses (if needed) are in place and up to date

» all software licenses are up to date; you are using legally registered versions of all software (it's tough to expect others to honor your copyrights if you don't honor theirs)

» you have an attorney on tap or know one you can call

» all of your building, vehicle, equipment and business liability insurance policies have adequate coverage and are and up to date

Your Office Space/Studio

» your work space is clean and well-organized

» you have an area for meeting clients (if this applies to your business) and that area looks professional and communicates your brand in all of its details

» your work space feels inviting and productive to you; it's a place you want to spend time in

» if your office is on your home property, all your utilities are paid for and accounted for separately from your home utilities, to the extent possible

» if you have a home office, it's set up for doing business only and is not also used as family living space (if you plan to claim home office deductions on your IRS returns)

Your Office and Marketing Materials

» your letterhead stationery, business cards, signs, brochures, logos, etc., are all consistent with one another, modernized and working together to create and communicate your brand

» all of your office supplies—envelopes, mailers, paper, etc.—are of high quality and communicate your brand

» if you use a printer to create some of your own materials, it is of high quality and produces a product that does not look computer-generated and home-made

Your Online Presence

» you have at least a basic website and it is up-to-date and functional (without those "under construction" pages that have been there since 1998)

» all of your online communications are consistent and reflect your brand

» you have an online slideshow and/or promo videos, highlighting you and your best work

» if you have a blog or any other running online content, you keep up with it regularly and its opinions and observations reflect your brand

» you don't have any embarrassing or unprofessional presences on sites like YouTube, MySpace or Facebook

Your Personal Presentation

» you have a professional wardrobe that reflects your brand

» you take care of your health and grooming

» you have a car that won't professionally embarrass you

» your personal look is fully consistent with your brand

» your assistants/employees reflect your brand in some way

Some Global Ideas to Keep in Mind

Regardless of which type of business you choose, you'll also want to keep these ideas in mind. They should be nuanced according to your model.

Remember What Brides are Really Looking For

When a bride is looking for a photographer, she will commonly say something like, "photography is really important to me." For the vast majority of brides, what that means is remembering the day well is important to them and they see photography as the vehicle for making that happen. Remembering the day well through photographs means they want those images to elicit feelings they want to have experienced or actually did experience on their wedding day. If the images are bad, of course, this will get in the way of the bride experiencing those feelings. But this is important to remember: the images do not have to be museum pieces either. The important thing is that they fulfill the function for which they are designed. That is, they work for the bride, not for you.

Think of it like a song that brings back a flood of feelings. A ten-thousand-dollar sound system isn't required to bring those feelings back. The sound just needs to be good enough. And, since most people don't have a trained ear, even if it were on a great stereo, the experience wouldn't be much richer.

Brides (and most people, really) know the difference between good photography and bad photography. But very few know the difference between good photography and great photography. So if your focus is more on being a brilliant photo artist than being a vehicle for feelings, you'll need to do some refocusing.

People Skills: The Antidote to Commoditization

Last fall, I happened upon a broadcast of the cable television show, *Platinum Weddings*. The narrator was describing the client's budget. What struck me wasn't how much was spent on the event, but how they broke it down. After describing the price of the cake, the dress and the shoes, they grouped the DJ, limousine and photography into one line item. A stark example of where our industry is headed. Commoditization.

How do we escape it?

On a recent flight from Canada, I had the good fortune to sit next to legendary great, Joe Buissink. Joe made the point that if there was one quality critical for avoiding becoming a commodity, it was *people skills*. When I asked him to tease that out, he outlined what he called, "the psychology of wedding photography." A psychologist by training himself, Joe said he leverages his knowledge of what people *need emotionally* at every stage in the photographer/client transaction.

He said, "Potential clients know who I am because of what other people say about me. It's my people skills that get me hired. Sure, there's a trust in my work and my style but *my* clients want their hands held, with good hands, and to believe that I am absolutely there for them,

from the heart. Taking care of their emotional needs is job one. And the result is my new clients become my referring clients. You can't fake or minimize that part of our work. It's an absolute pre-requisite."

Spend some time putting yourself in the place of your customers and imagining what their emotional needs might be at each step of the process. Where might they become confused? Where might some additional clarity help? Where will they need reassurances? Where might you listen instead of speak? Where might some humor and warmth be appreciated?

Be a relationship specialist and your wedding photography business will flourish.

Strengthen Your Backbone

By now, it should be clear that the only things you should be spending your time on are the things only you can uniquely do. In my mind, those things should be limited to shooting and marketing.

I have only one recipe for improving your shooting (marketing will take more work and will depend on the brand angle you choose). That recipe is this:

Take 100,000 Frames in the next year with people you want to learn from. Period. Do that and you'll be well on your way to technical expertise. Of course, along the way you will discover areas of technique development you'll want to invest in. When that happens, do what's required to progress (e.g., take a lighting workshop, buy a DVD on album pre-design and merchandising, etc.).

The combination of quantity shooting and quality training will make you unstoppable.

Automarket

When it comes to marketing you always want to get the most bang for

your buck. The goal is to make your marketing scalable. Meaning, you want to get more and more marketing value out of less and less *fuel* to drive that marketing effort. You want to create a marketing machine that will be virtually automated. That's what automarketing is all about. Everyone's automarketing system will be somewhat unique, but here are a few things to consider:

Word of Mouth (WOM)

The greatest automarketing tool in the world has not changed since the dawn of commerce: Word of Mouth. WOM is more important than any other tool in your arsenal. As a quick example, when I was seeking an editor for this book, I could easily have gone on Guru.com or Elance, but instead I asked my circle of colleagues. I was given a name of an editor, along with a strong recommendation, and I seized upon it. The greatest thing you can to do to promote WOM is to do excellent work and make your clients happy. Period.

Slideshows

One thing I do at every wedding I shoot (thanks to David Jay who introduced me to the concept) is to create an instant slideshow to display at the reception. I string together the best shots from the day and let the slideshow run on a laptop. It is meant primarily to entertain guests, but in the process, it also serves as a subtle marketing tool. Everyone who watches the "show" is seeing my work in a fun, artistic and entertaining light. Auto-running slideshows on your website, in the window of your business, or anywhere else you can creatively think to run them is a great way to market in your sleep.

Blogging

Running a blog is an excellent way to create a platform for your ideas, to communicate news about your business and to offer free tips and advice, all the while building and maintaining your branded presence and

creating a following. Create consistent, value-adding content for your target market and they'll keep coming back—and telling their friends about it in the process.

SEO (Search Engine Optimization)

When you're building your website, make frequent use of terms that people commonly use when they're doing online searches for your type of business. For example, "wedding photographer" or "wedding photography" and the name of your town. Website consultants can help you maximize your SEO presence.

Online Networks

Use forums and other online resources to create an online network with other photographers and related businesspeople. LinkedIn, for example, is a great online resource to leverage in that direction. Provide mutual links to one another's websites. Don't always try to "network up," network *across* with peers who have much to gain by mutually supporting and promoting one another.

"Expert" Advice

Numerous trade journals, websites, radio shows, newsletters, and other outlets are constantly seeking free content. Write a weekly "Ask the Expert" or "How To" column. Offer to appear as a guest on local or regional radio shows. Speak at business conferences. View all of this as free advertising.

Scaling at the Right Cost

Whenever you choose any kind of marketing or advertising, try to make it scale. That is, try to make it replicate or sustain itself in some way without increased input from you. A one-time ad in a Sunday paper gives you a quick burst of publicity, at a fairly high cost, which quickly dies out. Not a good strategy.

As Seth Godin suggests, "do something remarkable and make it easy for people to remark about you." Accomplish that and your marketing will scale very quickly as your fans talk on your behalf.

Why DIY is for Hobbyists

Whichever business model you choose, it's crucial to realize that Doing-It-Yourself—or rather, doing it *all* yourself—is a game you can't win. DIY is for hobbyists, not professionals. It won't empower your dream. It will only sap its potency.

I have a number of friends, for example, who are finish carpenters by specialty but general contractors by profession. The ones who thrive are the ones who keep their eye on the big picture while saving their favorite parts of the jobs for themselves.

Even though they have a working knowledge of framing, cement-pouring and bricklaying (and could do those jobs in a pinch, if needed), they are smart enough to *delegate* that work to others so that they can do the specialized work where they contribute the highest value. Working with select partners lets them pursue their passions and do the work that distinguishes them and their business, while letting others do the rest of the jobs.

They leave DIY for their hobby life.

All professional photographers, in my opinion, ought to spend as little time as possible on any aspect of their workflow that doesn't *require* their personal touch.

In my own case, given my Signature Brand business model, my pDNA, and the value I bring to the various tasks I'm responsible for, I don't believe it is wise for me to do *any* post-production work at all for large events I shoot. Until software can fully automate the tasks of editing weddings (Adobe is very close by the way), I've concluded that I should spend as little time as possible selecting, color correcting, raw convert-

ing, uploading and doing order fulfillment on my images. These are all tasks that I personally outsource and count my lucky stars that I do. As a result, beyond shooting and marketing my brand, I do very little time-consuming work and instead hire professionals to cover those bases for me. This allows me to do more concentrated high-value work—i.e. shooting and marketing - in the time I have available.

Making the Tough Choice

It's easy, of course, to outsource or delegate jobs you don't enjoy doing. For example, I don't like cleaning my bathroom. Outsourcing that task seems like a no-brainer. But when it's a task you inherently enjoy—but that still doesn't contribute *brand value*—that's when it's a tougher call to make.

For example, I actually do enjoy editing my pictures. The DIY'er in me loves getting an image just right in Photoshop. But if I'm fine-tuning thousands of images a week, my professional photographer business simply cannot prosper. The pro in me needs to make the hard call. Giving up that enjoyable, but ultimately delegate-able, task is simply a cost of doing business.

The same could be said of album design or website development or editing and typesetting this book. If I discover any task in my workflow that I realize could be done more effectively and efficiently by a special-ized professional, I pass it on.

I just wish I had figured this out sooner.

Taking responsibility for anything beyond what is uniquely yours to own and contribute is the cardinal sin of the *Fast Track Photographer* precisely because it fails to support the true business you are committed to.

When I get in conversations with dear friends and colleagues who re-sist the *Fast Track* mindset, the argument they always use is that since they *can* do a task for less money than an outsourced contractor, that they *should* do it themselves. What they don't recognize is that, due to

the flat nature of our new world, they are choosing to compete in a race they will ultimately lose in the long run.

Here's an example. I was recently on the phone with a professionally trained master photographer. He was lamenting three very specific challenges he found himself up against.

First, he was frustrated that so many new photographers were deceiving potential clients about the quality of their second-rate work. Second, as an event and corporate photographer, he was finding less and less joy in editing large volumes of images on his own. And third, he was dogmatically committed to the idea that he could never give up those aspects of his workflow (specifically editing) that "required" his touch.

In a nutshell, he was in a tragic Catch-22. (1) He loathed the young DSLR-toting crowd trying to steal his market share (that would be you), (2) he hated that he was up to his eyeballs in post-production labor and (3) he was totally antagonistic toward giving up control of an area of his business that would both free up his time to be more competitive and release him from the least life-enhancing parts of his job. In my opinion, if he doesn't change his course, he is headed down a one-way street to extinction despite his remarkable talent.

So which parts of your job should *you* make your central tasks and which ones should you delegate? I never advise a "one size fits all" approach. Each of us has unique "flavor" and make-up that should inform our decisions.

The goal, though, is to become a working professional. And professionalism is no longer defined as time served or dues paid. It's measured by the value you create and the wealth you produce. As the boss of your business, your job is to maximize those two things: value and wealth. Keeping that in mind at all times should help you prioritize which tasks are yours alone and which more rightfully belong to others.

DIT: the New DIY for Professionals

If DIY is ultimately for hobbyists, DIT (Doing It Together) is for professionals. DIT is the art of doing what you uniquely do best and outsourcing the rest. It is also the art of collaborating with colleagues in creative and mutually beneficial ways.

Understandably, for many who are just starting out as professionals, it's hard to justify spending money on outsourced services before becoming able to pay for such help. And in fact, the last thing I'd recommend is to go into debt before you earn enough to scale your business.

As we've already discussed, certain investments must be made in order to get started. For example, you need appropriate equipment (hardware and software) with back-ups in case your primary equipment fails. This includes camera gear and computer equipment. You will also need a means to display your work samples. Along those lines, you'll need graphic and web designers. You'll need business cards and office supplies. You'll also need to invest in a wardrobe that matches the brand you're creating. Finally, you'll need to cover your accounting and tax needs. These are baseline requirements to get started.

The great news, though, is that many of the costs of doing business can be handled at little or no expense if you use a bit of creativity. Why not connect with other up-and-coming professionals and offer trades of services? For example, if you need a web presence, why not offer a fledgling graphic designer a couple of free family photo sessions in exchange for a logo? Need to build up your portfolio? Why not huddle up with another new shooter and commit for the next year that you will both second-shoot each other's weddings in exchange for the ability to market the images you capture. Turn it into a competition as to who can book more weddings. Need more referrals? Make it your habit, every time you shoot an event, to actively plug your colleagues' services. Talk up colleagues on your blog, showing off how they made your event

better. I guarantee they will return the favor in time and that new refer-rals will come your way.

The possibilities for DIT collaboration are endless and will serve you more and more as you evolve as a professional.

It's Not About the Money, It's About the Future

In the beginning of my career, my rule of thumb when deciding wheth-er a task should be DIY or not was that if I could accomplish that work in less time and for less money than I could make by not taking on that chore, I would do it myself. Seemed logical enough.

In retrospect though, I stopped short of fully understanding this principle.

What I failed to recognize then and have come to believe now, is that, in this Digi-Flat world, all "lower end" tasks *will* ultimately be serviced *better* than I could ever pull off on my own, *and* for less and less money in the long run. These tasks will all eventually become commodities, whether by hardware, software or cheaper labor. It's inevitable. I fi-nally realized I was training myself in a skill-set destined to extinction through commoditization.

That said, I also believe there are certain tasks that can never become commodities. Those tasks will hold their value because of the scarce resource that is capable of uniquely performing them: you. Identifying what those tasks are is the number one job of the professional who wants to be around for the long haul.

As with gold or precious stones, limiting the *quantity* of an item is what makes it valuable. If I'm engaging in a task as a photographer that doesn't maximize the contributions that I, as a scarce resource, can *uniquely* con-tribute, then I am de-valuing the business I'm seeking to create.

Of course, if you are new to photography and have no working knowl-edge of some industry standard skills, it is critical that you develop

a reasonable degree of competence in these skills before outsourcing them. What that means is, even if your ultimate goal is to get rid of certain tasks, it is also your job to *understand* the tasks you're giving away so that: (1) you can ensure that the work is being done to a level that matches your brand and (2) so that if (i.e., when) things go wrong with your vendor, you are able to cover that base yourself.

So, treat tasks that you plan to eventually outsource as your training ground. Do them for a season and then pass them off. A basic foundation must be laid before you can responsibly hand a job off. Thankfully, the tools and skills to do this are getting more and more accessible.

A funny twist of fate is that the DIY approach to photography may be what got you in the game in the first place. Somehow a camera landed in your hands and you started pressing the shutter. The experience was magical. When it came to even the most basic of tasks, you did it yourself and it was good. A true amateur was born.

As a professional, however, the realities of the Digi-Flat Era demand a change in behavior but not a change of heart. DIT is the only way you'll transition from being a hired gun to being the owner of the gun that is hired.

Be the CEO

As you build your business, do it in such a manner that you don't get in your own way. Don't be a bottleneck to you own success. I like Timothy Ferriss' metaphor here: Imagine you're building a city—you want to be the mayor or the policeman, but not the person responsible for the utilities. Your job is to take your custom architectural guidelines (your pDNA) and "build a city" that doesn't require you to manually operate its mechanisms day in and day out. To the greatest extent possible, you want to set it up so that you only step in when there's a problem to solve. And after it's solved, you get out of the loop.

Another way to think about it is: the goal is to move beyond being a small business owner to being a CEO. A small business owner is the solo person who makes everything happen. In contrast, a CEO's job is to *make choices on resource allocation* to generate profit for its shareholders. As Robert Kiyasaki points out in his book, *Rich Dad, Poor Dad,* the distinction is critical.

Being the Photographer is the big cheese job. You should be the one who allocates resources and NOT the one who runs out to Staples to buy batteries. Your time is more valuable than that. If *you* don't believe it, no one else will. Let's say your time is worth *at least* $50 to $100 an hour. Would you pay someone $50 to go to the store and buy a $5 pack of batteries? Of course not! Then why waste your own valuable time this way? Your time is meant for higher purposes: building your business.

Of course, in the beginning there will be times when you *do* have to run out and buy the batteries, but always have an eye on how you can automate or delegate that task as soon as possible. Get things delivered. Use the Internet. Outsource. The temptation is to do everything yourself because your time and effort don't cost you money. You need to see that *they do cost you money.* They cost you the valuable time you should be using to create and build your one-of-a-kind, value-creating business.

A business that no one else in this Digi-Flat world will be able to replicate.

CHAPTER TEN
Parting Shots

Unprecedented Opportunity

Every time you hear some Grumpy photographer lament the good old days and curse the commoditized, competitive landscape we live in today, make it a habit to flip it around in your head. Remind yourself that every social and technological change holds within it vast new opportunities.

That's not just inspirational platitude, that's reality.

The very same forces that have been creating the radically level playing field of our Digi-Flat world offer you astonishing new ways to reinvent and market your work. As the Internet becomes ever more sophisticated and digs its fingers deeper into every aspect of our lives, the opportunities to target your "one thousand true fans" increase exponentially. You just need to be open to possibility and stay nimble on your feet.

Think about it. You now have the ability to reach virtually *every potential customer* in the industrialized world. That means you can be much more targeted in your approach. You no longer need to aim your sights at the lowest common denominator. That's old school thinking. New school thinking says you're free to create the most innovative, original and unique products and services you can think of, based on who you are, and let your customers *come to you*. Finding more effective ways to invite them into your life is becoming the definitive challenge.

Within a couple of years, *everyone* will have an Internet-enabled camera phone. As television becomes more interactive, the differences between your TV, your computer and your phone will continue to blur. The iPhone is just the beginning! Ads will be targeted, more and more, to specific consumers with specific needs and tastes. People will be buying more and more of their services right from their living rooms *as* they watch American Idol. Think there won't be a Bridal Channel on cable soon? With 24-hour wedding programming?

All of these changes are your friend, not your enemy. They offer you brilliant new ways to get yourself in front of your "true fans." As each

stunning new change occurs in this hyper-networked, telecommunicating world, I urge you to invest 0% of your energy in complaining, fearing and regretting it. Instead, *ride* the wave of possibility and imagine the bold new ways you can get your unique brand in front of the very people who crave it.

And please, be *pro*active, rather than *re*active. If you always wait until a new trend is firmly established before you act on it, you'll guarantee that you'll always be casting your net in over-fished waters. To the decisive boat captain go the sweetest fish!

An Integrated Life

As our old models for business crumble before our eyes, so too do our old models for a successful *life*.

Many of us were raised in the mindset that human beings must achieve satisfaction *sequentially,* rather than all at once. Let me explain what I mean by that. To live a successful life, we were taught to (1) find a job at which you could make good money (love of the job was unimportant), (2) invest your productive years in creating financial value, (3) put your relationships on hold till Sundays and vacations, and then (4) retire into the lifestyle you desired when your working years were done.

A much richer and saner model is emerging. It calls for living an *integrated* life in which we have the relationships, lifestyle, career and values we desire right *now*. Satisfaction is not put off until some nebulous end, but built right into the fabric of today. Where and how we live, what we do for income, who we spend our time with and the values we embrace all work *together* in the here and now, not at some imaginary time in the future.

As you look at your pDNA and think about the ideal Photographer business you will create, I encourage you to think in terms of integrating it with your whole life. Do you love the ocean? Then find a way to

live near it *now* and work it into your photography. Don't tell yourself why it can't be done. Look at any seaside community and you will see that a wide variety of people are finding ways to live and work there. And not all of them are rich.

Do you want to spend more time with your family? Then put your office in your home or shape your work week so that you're home the same hours your family is. Or find creative ways to *include* your family in your work.

Are your values oriented toward community and getting to know your neighbors? Offer your photo services to the community newspaper. As you photograph town meetings and local events in your spare time, you'll become a valuable part of the community *and* create a network of potential customers.

Life's goals don't have to unfold in linear fashion, like lengths of colored thread, tied together end to end. Rather, they can be like a tapestry in which *all* the threads are woven together and complementing one another, all the time.

Create Value

We've talked a lot in this book about creating value in the marketplace. That means bringing something unique and marketable to the table in a way that no one else is precisely doing. It means seeing yourself as a brand that represents a creative solution to someone else's needs. These are critically important ideas.

I would like to encourage you, though, to think about creating value in an even higher way, too. That is: create positive value *in the world*. Add something good to the planet. Make the world a better place through the work you do.

If you vow, right from the start of your business, that you are going to use it to make a contribution to the world, in whatever way you con-

ceive, then I guarantee your business will take on a new dimension of satisfaction and meaning that it will never have if you keep your eyes only on the commercial marketplace.

There are endless ways to create positive value through your work. Value can be created through the beauty of the images you shoot, through the way you honor the commitment of marriage, through the honesty with which you do business, through the caring way you listen and relate to others, through the investment of some of your business profits in worthy causes, through the spirit you exude when you're shooting an event, through the respectful workplace you create, through the generosity you exhibit in your networks, through the "pro bono" work you do, etc., etc., etc.

If you build your business on the principle of making the world a better place, day in and day out, you will have concocted an amazingly effective antidote to burnout and Grumpiness. Paradoxically, the more you focus on bringing value to others and the less you focus on bringing value to yourself, the more success will inevitably circle back to you. It's just one of those mysteries of the universe.

Keep the End in Sight

As you look at the actions you're taking today in creating your life and business, I encourage you to do a little mental exercise that wise people from many spiritual (and non-spiritual) traditions often employ. It may sound a bit morbid, but it is not.

It's to vividly imagine your own demise.

We're all dying. How are you living? How do you want to look back on your life at the end? What are the values you'll want your life and career to have been about? What goals will you want to have accomplished? What sorts of things do you want to leave behind as your legacy?

Are you working toward those ideals now? I mean *right* now, this Tuesday afternoon. Are the choices you're making right here, right now, leading

you closer to the career and life you will want to have lived? Or are they leading you further away? Or are they leading nowhere at all?

I encourage you to think about your "end" every morning when you begin your day. Not to make you feel depressed or down, but to make you appreciate the gift and opportunity you have in every waking moment of this day to create the life you truly value.

If you're holding your best efforts in reserve…why? When is the "someday" you imagine pulling out all the stops? What are you gaining by holding back? When do you think you'll get an opportunity to use the courage, energy, creativity and vision you're keeping in store?

There is an expression in sports: "Leave it on the field." It means bringing your best effort to every moment of the game, so that when the final whistle blows, you've held nothing in reserve. In 2008, the New York Giants beat the New England Patriots in the Super Bowl. Not because they were a more talented team. Not because they were better coached. But for the simple reason that they didn't hold anything back. They *brought it* on every play.

When the game is over for you, wouldn't you like to know you "left it all on the field"? Then what are you waiting for? Boldly imagine the Photographer business of your dreams and start making it real, right now, in every tiny decision you make.

I'm incredibly excited about what you will become.